IMAGES
of America

CAMP CLARK

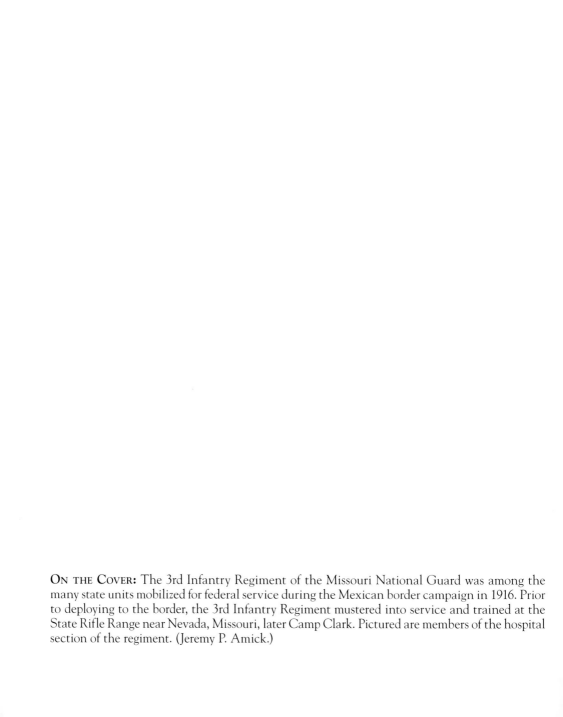

ON THE COVER: The 3rd Infantry Regiment of the Missouri National Guard was among the many state units mobilized for federal service during the Mexican border campaign in 1916. Prior to deploying to the border, the 3rd Infantry Regiment mustered into service and trained at the State Rifle Range near Nevada, Missouri, later Camp Clark. Pictured are members of the hospital section of the regiment. (Jeremy P. Amick.)

IMAGES
of America

CAMP CLARK

Jeremy P. Amick
Foreword by Charles Machon

ARCADIA
PUBLISHING

Published by Arcadia Publishing
Charleston, South Carolina

Printed in the United States of America

Library of Congress Control Number: 2022943878

For all general information, please contact Arcadia Publishing:
Telephone 843-853-2070
Fax 843-853-0044
E-mail sales@arcadiapublishing.com
For customer service and orders:
Toll-Free 1-888-313-2665

Visit us on the Internet at www.arcadiapublishing.com

*To the impressive and dedicated men and women of the Missouri
National Guard, who have built, expanded, and continued
the legacy of the State Rifle Range and Camp Clark.*

CONTENTS

FOREWORD

This work by Jeremy Amick tells the story of Camp Clark from its inception to the present day. He notes how Camp Clark has a long and celebrated history and, over the years, was named for several different military or state leaders. It was not until the death of Brig. Gen. Harvey Clark, the site's first commander, that it received its current name.

Camp Clark was the site where approximately 6,000 Missouri National Guard soldiers were mobilized for duty on the Mexican border in 1916, and at least 10,000 soldiers were mobilized for duty in World War I in 1917. During the war, hundreds of Missouri Home Guard soldiers trained there as well.

After the war, Camp Clark resumed its original role as a summer training site for the Missouri National Guard. It was at this time the 110th Observation Squadron also utilized the site. One of its members, Charles Lindbergh, later went on to be the first person to successfully fly solo across the Atlantic, in 1927. During the Great Depression, federal funds via the Works Progress Administration were used to construct improvements at Camp Clark. The first permanent barracks were built and various permanent support facilities constructed.

Amick continues telling the story of how the Missouri National Guard did not mobilize at Camp Clark during World War II. Camp Clark was taken over by the military and used at first as an Italian prisoner of war camp until Italy's surrender in 1943. Later, German prisoners captured during the North Africa campaign were interred at Camp Clark. Camp Clark was returned to the Missouri National Guard after the war ended, when it resumed its role as a summer training site.

Since then, Camp Clark has continued to provide valuable training for Missouri National Guard soldiers. During the Global War on Terror, Camp Clark saw thousands of Missouri National Guard soldiers train there for various missions, both stateside and overseas. Camp Clark will continue to be a valued training site for the Missouri National Guard.

—Charles Machon
Director, Museum of Missouri Military History

ACKNOWLEDGMENTS

I can never stress enough that works such as this book represent a collective effort. First, I want to offer my unyielding gratitude to 1st Sgt. (retired) Frank Arnold. A resident of Nevada, Missouri, Arnold worked at Camp Clark for several decades, and the historical insight he provided was of significant benefit. Secondly, Brig. Gen. Charles Hausman granted me permission to access the post to conduct my research and take photographs. Charles Machon and Douglas Sheley with the Museum of Missouri Military History have been my crutch on several Missouri military history pursuits, and this book was no exception—thank you both for all of your assistance. The staff at the Bushwhacker Museum in Nevada are quite knowledgeable on area history and graciously allowed me to use several photographs for this project. If you have a chance to visit the Bushwhacker Museum, it is an experience that will not disappoint. Finally, I am abundantly grateful to Capt. Jason Van Note and his fellow fulltime soldiers at Camp Clark; the hospitality you extended me is not forgotten.

Introduction

During my own tenure as an enlisted soldier in the Missouri National Guard, I often visited Camp Clark to pick up ammunition for weapons qualifications or to attend a training event. At the time, when I was still wearing a military uniform and embroiled in whatever momentary duty confronted me, I tended to overlook any historical significance in my midst. In later years, while I was stationed at Jefferson Barracks in St. Louis, I truly began to acquire an interest in the history associated with various military sites in the state, especially those associated with the state militia or, as it later became known, the Missouri National Guard.

Established in 1908 as the State Rifle Range, this Nevada-area training site has become something of an enduring memorial to one of the most iconic figures in Missouri National Guard history—Brig. Gen. Harvey C. Clark. Not only was he instrumental in modernizing the Missouri National Guard following the passage of the Dick Act, which provided more federal funding for the National Guard and helped formalize training, he began his association with the National Guard when he enlisted as a private in 1888. In his civilian life, Clark completed the schooling to become a lawyer while maintaining his association with the military as a guardsman. Rising through the ranks, he deployed to Cuba as a lieutenant colonel with the 6th Missouri Volunteer Infantry Regiment during the Spanish-American War. The year 1899 was a watershed moment in the 29-year-old's military career, since he was appointed as a brigadier general and ushered in a major reorganization of the Missouri National Guard.

For many years after the establishment of the State Rifle Range near Nevada, General Clark, in his role as commanding general of the Missouri National Guard, oversaw the training during annual encampments. In 1916, it was at the State Rifle Range that the state's guardsmen mobilized for service in the Mexican border campaign. General Clark's popularity among the troops resulted in the site being called Camp Clark years prior to its official designation as such. Sadly, during World War I, his role as commanding general was suspended when an underlying health condition was identified, and he was not allowed to deploy to France with the state's troops, many of whom had first mobilized at Camp Clark. He remained stateside, and after being appointed the adjutant general of the state, advocated on behalf of all Missouri soldiers while striving to ensure that the legislature and other organizations provided the benefits these heroes deserved upon their return from World War I. It is of little surprise that after General Clark's untimely passing in 1921, the State Rifle Range was officially designated Camp Clark.

The next few years in the camp's history were defined by growth and expansion as the site grew to encompass 1,287 acres, and new, more permanent buildings began to dot the landscape during the Great Depression. Summer encampments became major events as thousand of the state's troops poured into the southwestern Missouri community of Nevada to conduct military training. Several notable Missourians such as Charles Lindbergh trained there. Years later, during World War II, the camp transitioned to federal control. It was at this time that a camp to hold Italian prisoners of war was established; later in the war, Germans were held at the site. After the

war, it was believed that the camp would be sold at auction, but through the efforts of many in the Nevada community, it returned to the control of the Missouri National Guard and its prior usage as a rifle range and encampment location for the state's troops.

Through continuing investments by the Department of Defense and the Missouri National Guard, Camp Clark remains a viable and vibrant training site for the state's troops and has even been utilized for pre-mobilization training by National Guard soldiers from both Kansas and Missouri. Many updates and improvements to facilities and training sites are being made to this historic rifle range that was established well over a century ago. Although the original rifle range is no longer being used, it remains a visible example of how far the camp has developed and provides the occasional whisper of the site's rich past. Camp Clark has a story that is still being written and has many additional years of benefit to offer to the state and the Missouri National Guard. Enjoy this exciting view into the history of Camp Clark, and thank you to the dedicated members of the Missouri National Guard who have become an embedded part of its enduring legacy.

One

BUILDING THE
STATE RIFLE RANGE

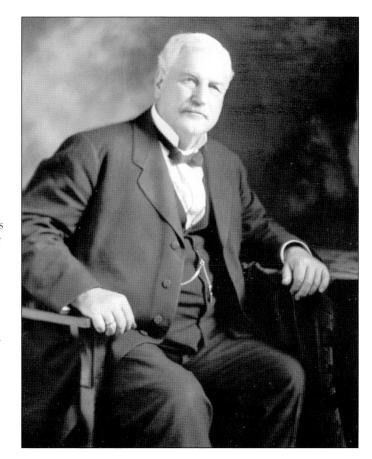

Large-scale training events in the Nevada community by the Missouri National Guard began in 1901. During the summer of this year, the Missouri National Guard held an encampment on 120 acres designated Camp Dockery near the Missouri State Hospital for the Insane. Pictured is Missouri governor Alexander Dockery, for whom the encampment was named. (Jeremy P. Amick.)

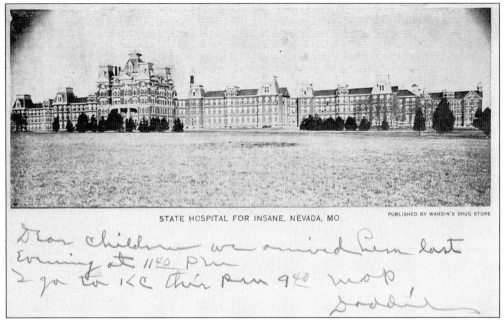

STATE HOSPITAL FOR INSANE, NEVADA, MO.

PUBLISHED BY WARDIN'S DRUG STORE

Dear Children — we arrived here last Evening at 11:40 P.M. I go to K C this P.M. 9:40 — Daddie

Decades prior to the establishment of the State Rifle Range, the State Hospital for the Insane (Nevada State Hospital), constructed in 1887, became an impressive landmark in Nevada. Training at Camp Dockery in 1901 took place just to the north of the hospital on land that was described as possessing a high elevation with excellent drainage. (Jeremy P. Amick.)

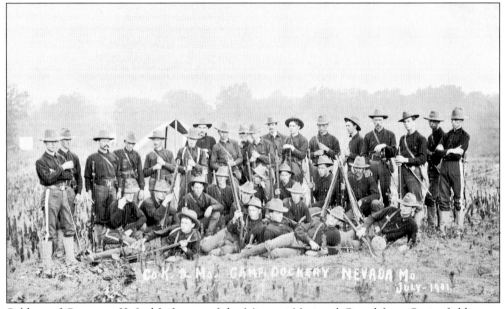

Soldiers of Company K, 2nd Infantry, of the Missouri National Guard from Springfield pause for a photograph while participating at an encampment at Camp Dockery near Nevada in the summer of 1901. It was reported that 2,000 Missourians arrived at the camp on July 25, 1901, to witness a sham battle overseen by Brig. Gen. Harvey C. Clark, who was at the time commanding general of the Missouri National Guard. (Jeremy P. Amick.)

12

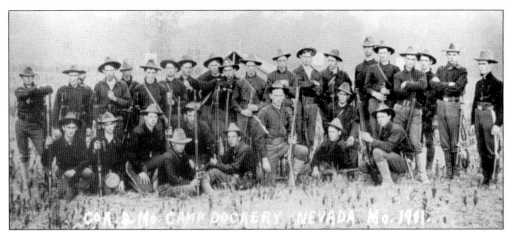

Soldiers assigned to Company A, 2nd Missouri Infantry Regiment, pose for a photograph during their training at Camp Dockery in July 1905. The *St. Louis Republic* reported, "The discipline of the camp is excellent. The men and officers say the regiments are better disciplined and made up of better men this year than ever before." (Museum of Missouri Military History.)

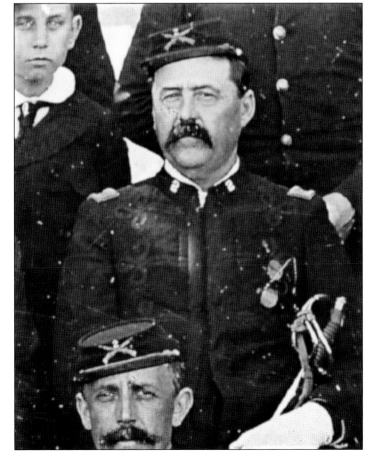

Col. Harrison "Harry" Mitchell was a Union veteran of the Civil War, served in the Spanish-American War, and organized the first Missouri National Guard company in Nevada. He later commanded the 2nd Missouri Infantry Regiment and was described as a "gallant commander" by his contemporaries. Colonel Mitchell was a role model for many early leaders of the Missouri National Guard and was considered the "military father" of Gen. Harvey Clark. (Jeremy P. Amick.)

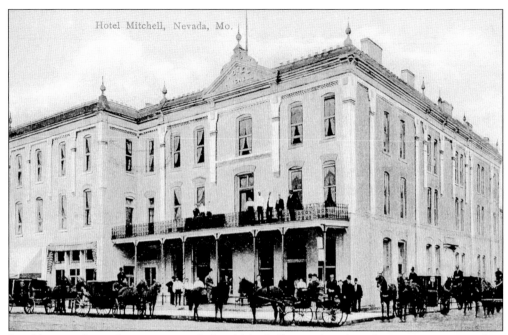

Hotel Mitchell, Nevada, Mo.

In addition to his military pursuits, Colonel Mitchell contributed to the economy surrounding Camp Clark by building the Hotel Mitchell after he moved to Nevada in 1878. The hotel was considered a pioneer establishment of the city and was sold by Colonel Mitchell to W.S. Goodrich in 1915. Remnants of this historic building still exist in downtown Nevada. (Jeremy P. Amick.)

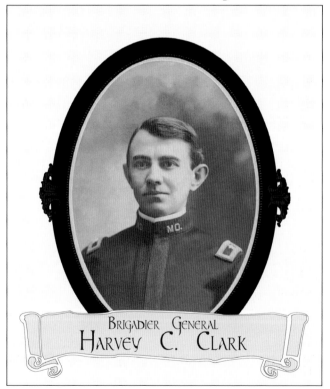

BRIGADIER GENERAL
HARVEY C. CLARK

Harvey C. Clark began his career with the Missouri National Guard in 1888, when he helped organize Company B, 2nd Regiment, and was elected its captain. After later organizing the 6th Missouri Volunteer Infantry Regiment, he served as its commander during the Spanish-American War and was shortly thereafter promoted to brigadier general. He helped oversee a major reorganization of the Missouri National Guard in 1900. (Museum of Missouri Military History.)

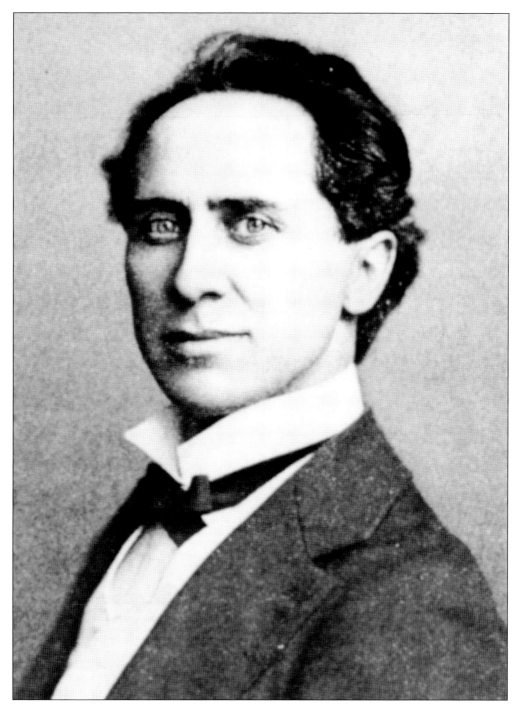

The structure of the National Guard changed with the passage of the Militia Act of 1903, otherwise known as the Dick Act. This legislation was sponsored by and named for a US representative from Ohio, Charles Dick, and helped provide federal funds and resources for maintaining and equipping the National Guard, which also later helped in the construction of military training sites. (Museum of Missouri Military History.)

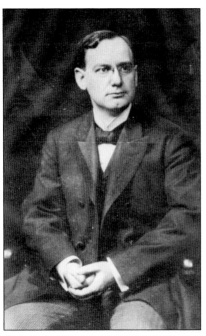

During the administration of Missouri governor Joseph W. Folk (1905–1909), pictured, a commission was appointed to select a headquarters and training site for the Missouri National Guard. This commission included the Missouri National Guard leadership of Gen. Harvey Clark, commanding general, and Brig. Gen. James DeArmond, adjutant general. This team was supplemented by Maj. William L. Chambers, an inspector–small arms practice. (Jeremy P. Amick.)

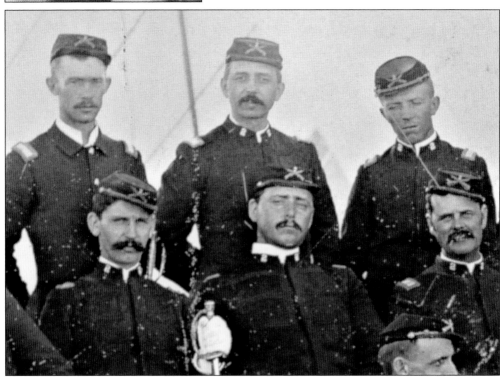

In the years prior to this commission, federal inspectors urged the construction of rifle ranges for training the National Guard within their respective states. In his annual report from 1905, adjutant general of the Missouri National Guard James DeArmond maintained that rifle practice by Missouri soldiers was best described as "irregular." DeArmond is pictured in 1898 (back row, center) while serving as a lieutenant during the Spanish-American War. (Jeremy P. Amick.)

The establishment of the State Rifle Range occurred during the administration of Governor Folk on April 28, 1908, when the US government purchased 320 acres for $12,800 on what is currently the southwest corner of Camp Clark, south of the Nevada State Hospital. However, the camp began to truly take shape the following year under the administration of Gov. Herbert Hadley (pictured). Prior to the purchase, several potential locations in the state were considered for the rifle range and encampment site. (Jeremy P. Amick.)

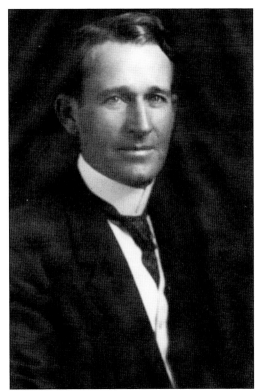

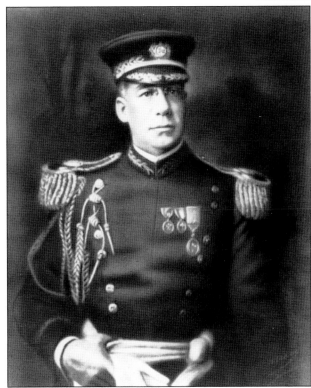

Pictured is Brig. Gen. Frank Rumbold, who became adjutant general of the Missouri National Guard during the administration of Governor Hadley. In the summer of 1909, the first Missouri National Guard troops trained at the new site in Nevada under the leadership of Gen. Harvey Clark. Governor Hadley, accompanied by Generals Rumbold and Clark, reviewed the 2,300 Missouri guardsmen who were in training when visiting "Camp Hadley" on July 21, 1909. (Museum of Missouri Military History.)

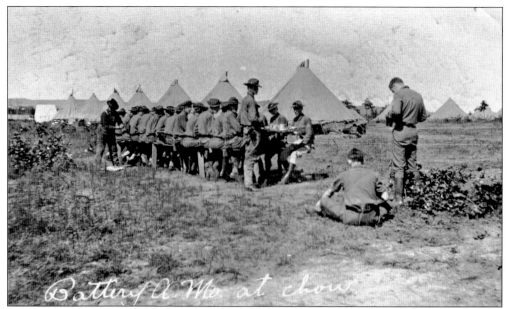

Soldiers of Battery A from St. Louis are pictured enjoying a meal during a break from their training at the State Rifle Range/Camp Hadley in the summer of 1909. Eight men of Battery A in addition to 48 from the 1st Regiment of the Missouri National Guard departed St. Louis on July 15, 1909, to prepare the new training site for the arrival of the rest of the state's troops. (Jeremy P. Amick.)

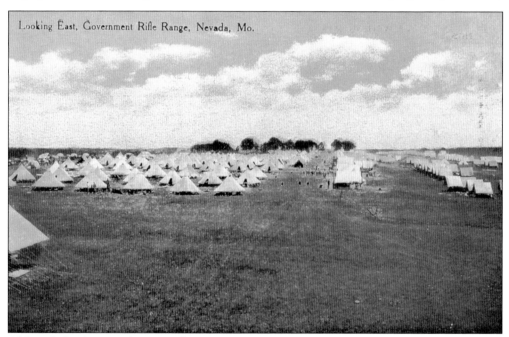

Although for the next few years the training site was occasionally referred to as Camp Hadley, it was officially named the State Rifle Range in 1908 and was located in Vernon County near the city of Nevada. The terrain of the camp consists of open fields (as pictured in this vintage postcard) along with sections of rolling woods, providing a range of training environments for Missouri guardsmen. (Jeremy P. Amick.)

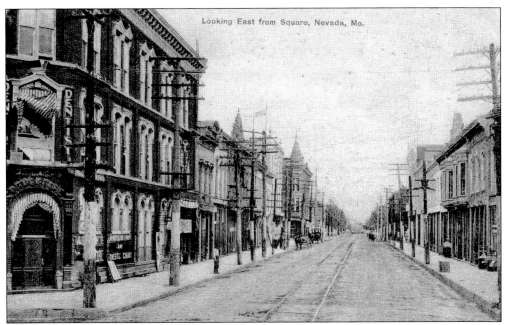

With Joplin 60 miles to the south and Kansas City approximately 100 miles to the north, Missouri soldiers training at the State Rifle Range were inclined to visit the nearby community of Nevada if they were they granted any downtime during training. This postcard, dated 1908, the same year the rifle range was established, shows the main square in downtown Nevada. US Census data show the population for Nevada in 1910 was 7,176. (Jeremy P. Amick.)

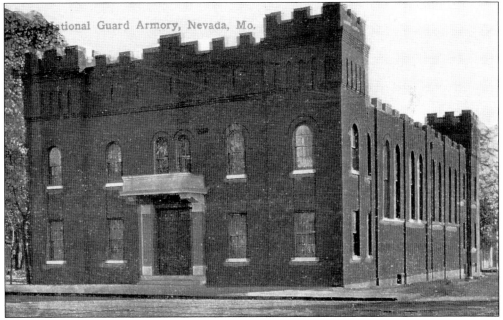

Public support for the Missouri National Guard was great in the Nevada community. This postcard shows the armory that was built in Nevada in 1909 and financed through the subscription of funds from private donors. The previous year, the community of Nevada helped raise $6,000 to defray the costs of building a rifle range at the newly selected site. (Jeremy P. Amick.)

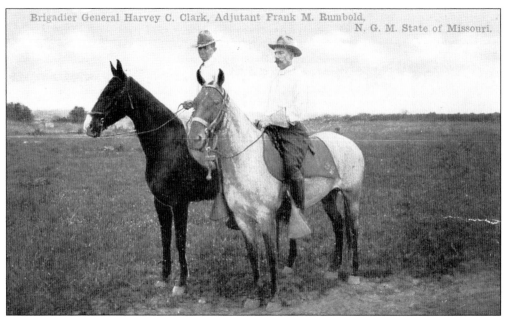

Brigadier General Harvey C. Clark, Adjutant Frank M. Rumbold,
N. G. M. State of Missouri.

Brig. Gen. Harvey Clark, left, and adjutant general Frank Rumbold were important figures in the early development and expansion of the State Rifle Range. In the summer of 1910, officers and noncommissioned officers of the Missouri National Guard attended a two-week encampment at the rifle range near Nevada while privates traveled to Fort Riley, Kansas, for training. (Jeremy P. Amick.)

The 1910 encampment at the State Rifle Range was unique in that a wireless telegraph apparatus was installed to facilitate communication between different sections of the camp. However, basic communications still consisted of wire strung along poles, as seen in this photograph taken during the 1910 encampment. (Museum of Missouri Military History.)

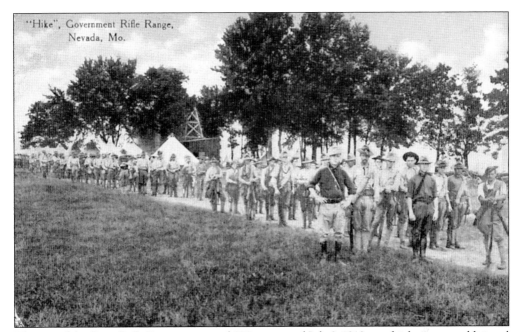

"Hike", Government Rifle Range, Nevada, Mo.

The size of the State Rifle Range remained 320 acres until July 9, 1912, at which time an additional 123.4 acres were purchased from S.P. Keyes for $5,100. This additional acreage would be beneficial when the site was used by increasing numbers of guardsmen for marches and hikes in the coming years. (Jeremy P. Amick.)

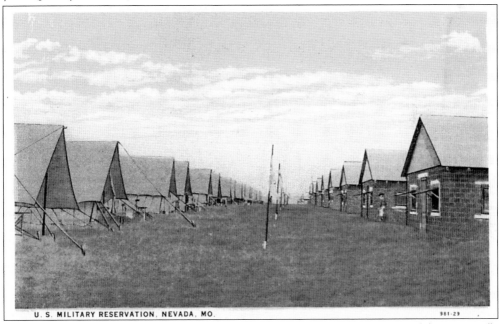

U. S. MILITARY RESERVATION, NEVADA, MO.

Many investments were made in permanent structures after the establishment of the State Rifle Range. Within a few years, improvements were made that included the construction of a brick storehouse, a wooden latrine and bathhouse, a storage tank, a water system, and rifle pits. In June 1910, cadets from the University of Missouri in Columbia witnessed many of these improvements while undergoing military training at the rifle range. (Jeremy P. Amick.)

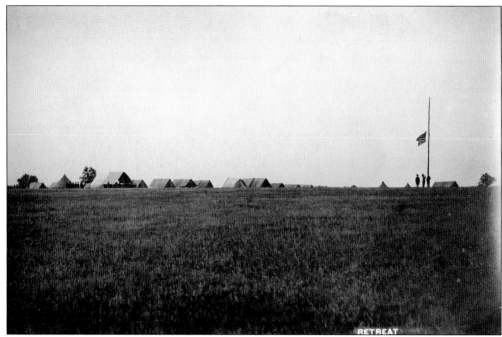

"Retreat," the time-honored ceremony marking the end of the military workday, is signaled by the lowering of the flag during an encampment of the Missouri National Guard at the State Rifle Range in 1911. (Museum of Missouri Military History.)

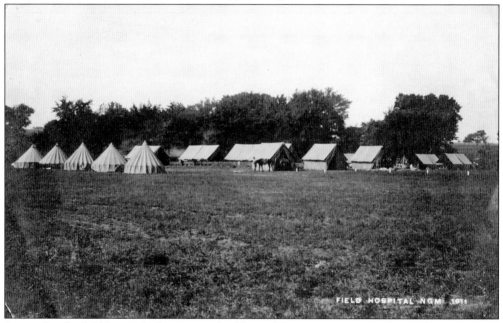

Pictured is the field hospital where injured soldiers of the Missouri National Guard could receive medical attention during the annual encampment at the State Rifle Range in August 1911. Shortly before the encampment, Gen. Harvey Clark announced the appointment of Dr. Oliver C. Gebhart of St. Joseph, who a few years later served in World War I, as the chief surgeon of the Missouri National Guard. (Museum of Missouri Military History.)

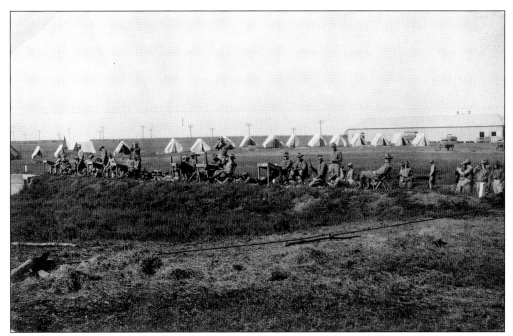

In early July 1911, Brig. Gen. Harvey Clark issued orders to Company A, 2nd Missouri Infantry Regiment, of Nevada and Company B of Butler to travel to the State Rifle Range twice a month for the remainder of the summer to conduct rifle practice. Transportation and rations for these training events were furnished by the state. (Museum of Missouri Military History.)

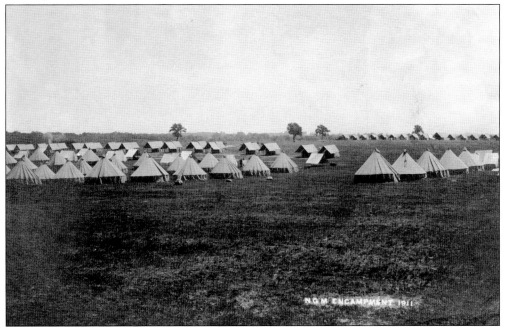

The Missouri Pacific Railroad constructed a spur from Nevada to the State Rifle Range to accommodate the influx of troops to the area during annual encampments. Pictured is the encampment in August 1911, during which about 2,500 soldiers from the five regiments of the Missouri National Guard were in attendance. (Museum of Missouri Military History.)

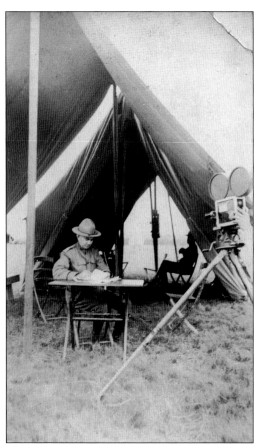

As the commanding general of the Missouri National Guard, Brig. Gen. Harvey Clark (pictured), a resident of Nevada, established the headquarters section for the annual encampment at the State Rifle Range in 1911. Also in the headquarters section was Frank Rumbold, the adjutant general. (Museum of Missouri Military History.)

The encampment of the Missouri National Guard was held at the State Rifle Range in July 1912. During the encampment, there were joint maneuvers conducted between the soldiers of the Missouri National Guard and the 7th US Infantry of the Regular Army. (Museum of Missouri Military History.)

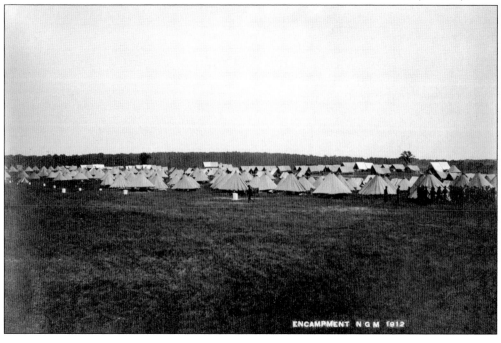

Missouri governor Elliot Major, pictured, received a telegram from Gen. Harvey Clark on August 25, 1913, stating that 2,436 members of the Missouri National Guard were in training at the State Rifle Range. According to General Clark, this represented the largest encampment in the history of the Missouri National Guard. (Jeremy P. Amick.)

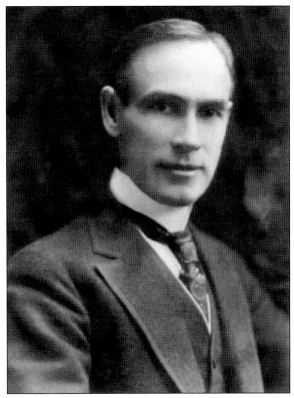

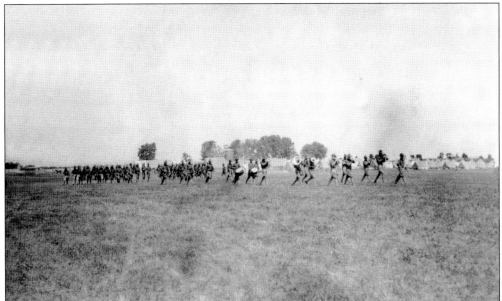

Several companies held weeknight drills, practice marches, and overnight encampments prior to the annual encampment at the State Rifle Range in 1913 so that they would arrive at the training in a prepared manner. An enticement for many young men to enlist in the Missouri National Guard was that they were to receive Regular Army pay and expenses paid by the state during their training. (Museum of Missouri Military History.)

A 13-year-old Samuel James Jr. is pictured in late August 1913 at the annual encampment of the Missouri National Guard at the State Rifle Range. The young James was attending with his father, Maj. Samuel James Sr., a prominent attorney from Sedalia and a Spanish-American War veteran. The younger James served in the US Navy in World War I. (Jeremy P. Amick.)

The State Rifle Range was known by many titles in the first few years of its existence, at times being named for the governor of the state or known as the Government Rifle Range. However, troops training at the Nevada-area site soon gave it the unofficial moniker of "Camp Clark" out of respect for Brig. Gen. Harvey Clark, commanding general of the Missouri National Guard and a Nevada resident. (Jeremy P. Amick.)

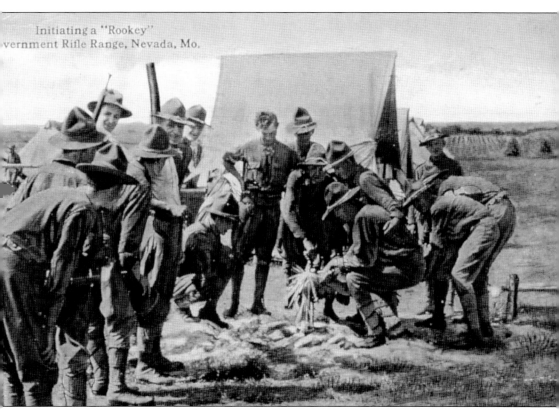

Initiating a "Rookey"
vernment Rifle Range, Nevada, Mo.

Regular summer encampments and training events continued for the Missouri National Guard at the State Rifle Range, as depicted in this vintage postcard. In the summer of 1914, Capt. A.C. Dunlop was appointed the superintendent of the rifle range and lived with his family in a house built on the site. (Jeremy P. Amick.)

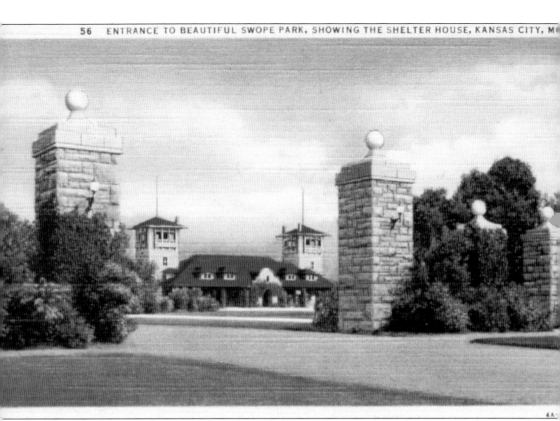

Many regiments within the Missouri National Guard established locations near their home stations to conduct training exercises and rifle practice prior to the development and expansion of the State Rifle Range. In September 1915, Company F, 4th Regiment, conducted training at Swope Park in Kansas City, Missouri. The troops named their temporary training site Camp Clark six years before the State Rifle Range in Nevada officially acquired that title. (Jeremy P. Amick.)

Two

MEXICAN BORDER CAMPAIGN AND WORLD WAR I

Mexican revolutionary Francisco "Pancho" Villa unexpectedly became an impetus to the early growth of the State Rifle Range. In 1916, he and his small army conducted raids along the border between the United States and Mexico, killing a number of US soldiers and citizens in a community in New Mexico. This resulted in a pursuit of Villa and his soldiers followed by the mass mobilization of the National Guard of several states. (Jeremy P. Amick.)

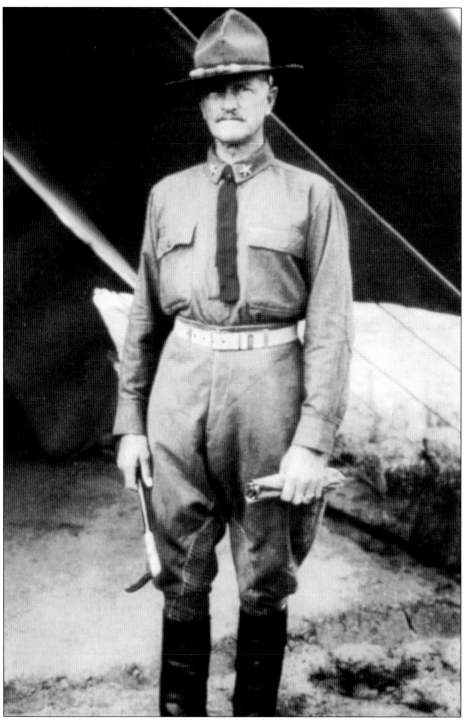

In response to these border raids, Brig. Gen. John J. Pershing, a Missouri native, commanded a punitive expedition into Mexico in pursuit of Pancho Villa. Soon it would expand into a large-scale expedition involving not only the US Army but also National Guard soldiers from Missouri. (Jeremy P. Amick.)

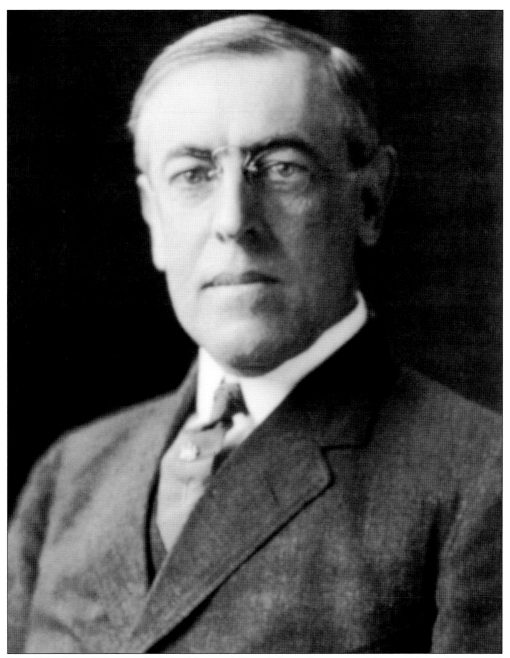

Pres. Woodrow Wilson called the National Guard from the states of Texas, New Mexico, and Arizona into federal service on May 9, 1916, in response to the growing crisis on the border. On the evening of June 18, 1916, the Missouri National Guard received the call into federal service, and the state's regiments began mobilizing at the State Rifle Range in Nevada. (Museum of Missouri Military History.)

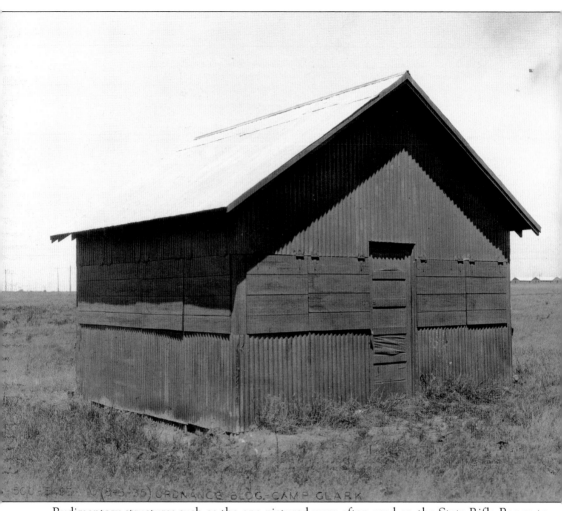

SOUTHEA... (8-8-35) ORDNANCE BLDG.-CAMP CLARK

Rudimentary structures such as the one pictured were often used on the State Rifle Range to store ammunition and related supplies. These structures were removed in later years and replaced with updated and safer storage facilities. (Museum of Missouri Military History.)

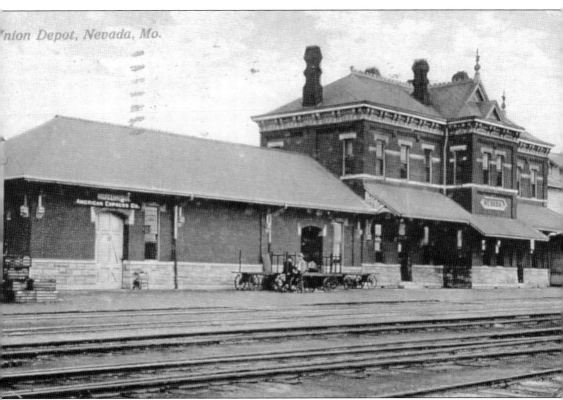

In response to the president's call, the entire Missouri National Guard was mobilized and assembled at their home stations. The 1st Regiment, from St. Louis, was the first to reach Camp Clark and was inducted into federal service on June 25, 1916. The majority of the troops traveled by special trains to Nevada, arriving at the Union Depot. The brigade headquarters had been established at the State Rifle Range on June 19, 1916, and was prepared to receive the influx of the state's troops. (Jeremy P. Amick.)

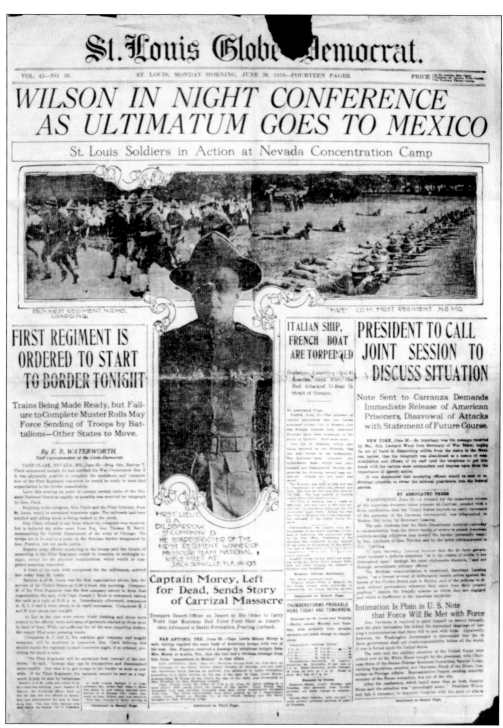

The *St. Louis Globe-Democrat* reported on June 26, 1916, that the 1st Regiment of the Missouri National Guard was prepared to board trains at the State Rifle Range and depart for service along the Mexican border. The newspaper also revealed that the rifle range was being referred to as Camp Clark. (Museum of Missouri Military History.)

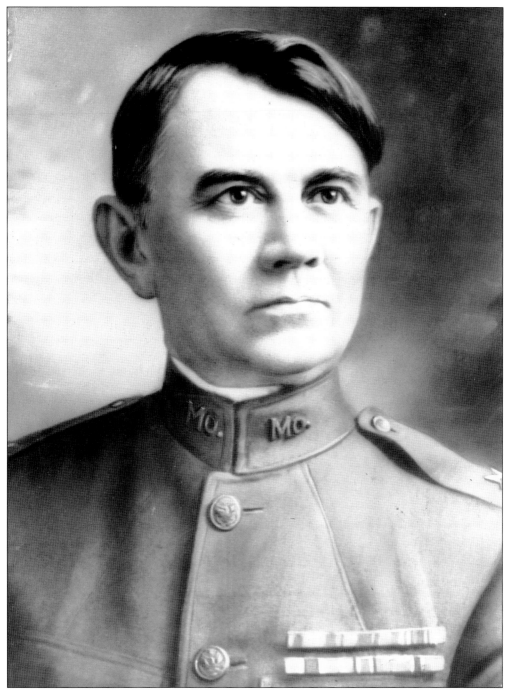

Brig. Gen. Harvey Clark, pictured, the commanding general of the Missouri National Guard, worked quickly at Camp Clark to coordinate the receipt of supplies to equip his troops deploying to the Mexican border. He remained in contact with Maj. Gen. Thomas Barry, commander of the Central Department at Chicago, regarding his progress on movement to Texas. (Museum of Missouri Military History.)

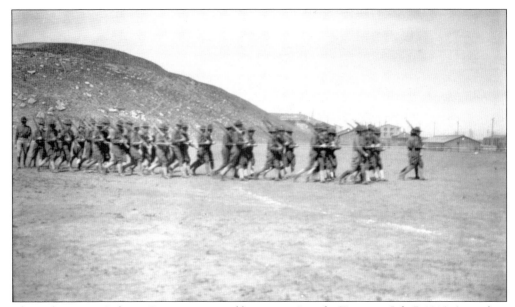

The 2nd Missouri Infantry Regiment arrived by train in Laredo, Texas, on July 7, 1916. According to a Missouri National Guard history, it then marched approximately two miles to its permanent camp, which happened to possess unpleasant odors since it was still being used as a public dumping ground for the city of Laredo. (Museum of Missouri Military History.)

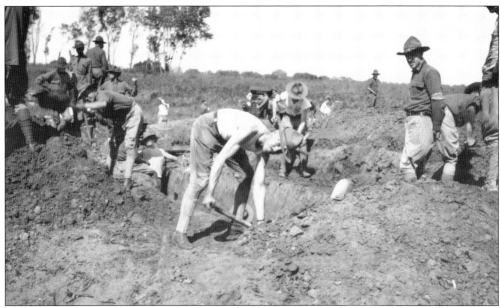

More than 5,000 Missouri National Guard troops, under the command of Brig. Gen. Harvey Clark, supported operations in an area defined as the Laredo District. This district extended for approximately 100 miles up and down the Rio Grande. (Museum of Missouri Military History.)

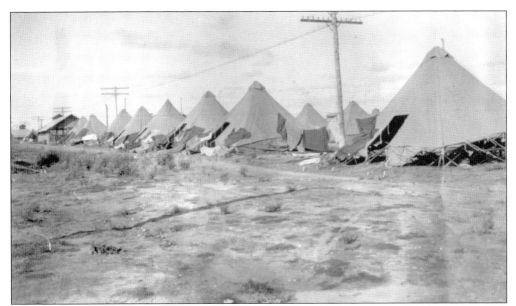

When the 2nd Regiment of the Missouri National Guard arrived in camp in early July 1916, it was raining and the conditions were quite muddy. However, it soon turned dry, and dust storms, along with ants, became a constant annoyance to the troops. (Museum of Missouri Military History.)

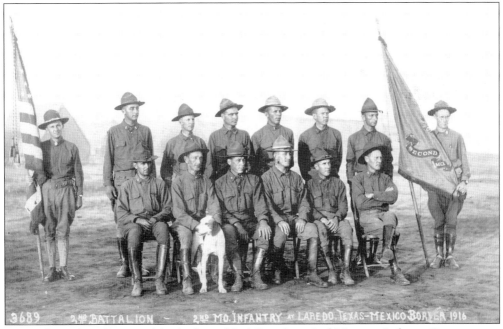

Pictured are the officers and leadership of 2nd Battalion, 2nd Missouri Infantry Regiment, in Laredo, Texas. Border patrols became a necessity in the Laredo District, which were conducted by soldiers of the 2nd Infantry on an intermittent basis. (Museum of Missouri Military History.)

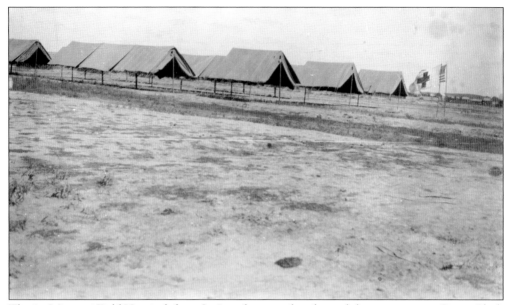

The 1st Missouri Field Hospital, from St. Joseph, arrived at the mobilization camp at Camp Clark on June 21, 1916. Five days later, it was mustered into federal service, and departed for the Laredo District on July 8, 1916. The unit mustered out of federal service at Fort Riley, Kansas, on January 5, 1917. (Museum of Missouri Military History.)

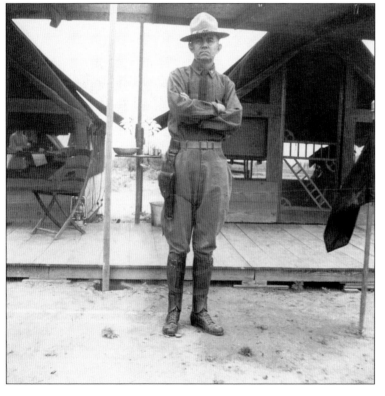

A stoic Brig. Gen. Harvey Clark is pictured in late 1916 while commanding Missouri National Guard troops in the Laredo District. The 4th Missouri Infantry Regiment engaged in field maneuvers and organized patrols along the Rio Grande, the latter of which earned it praise from General Clark. The 4th Infantry was released from federal service on February 21, 1917. (Museum of Missouri Military History.)

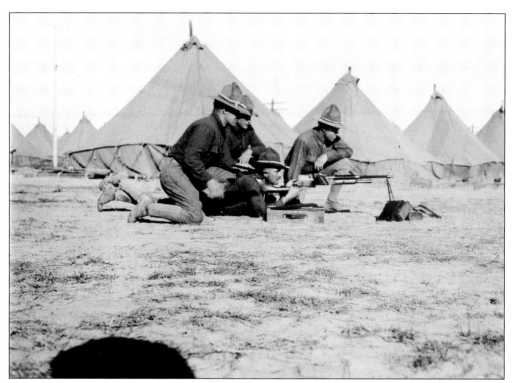

While soldiers of the Missouri National Guard were enduring field training in the unyielding heat of the Laredo District, back in Missouri, efforts were underway to open recruiting substations to help grow the guard to the full authorized strength of 100 soldiers in each company. (Museum of Missouri Military History.)

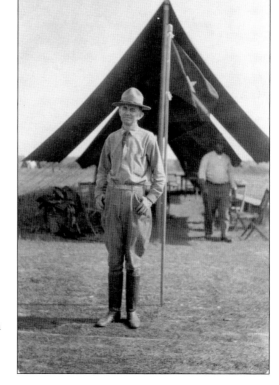

Harvey Clark, whose name was being associated with the State Rifle Range during the ramp-up for deployment and who commanded the brigade of Missouri National Guard troops sent to the Mexican border in 1916, had been commissioned a brigadier general on February 2, 1899. (Museum of Missouri Military History.)

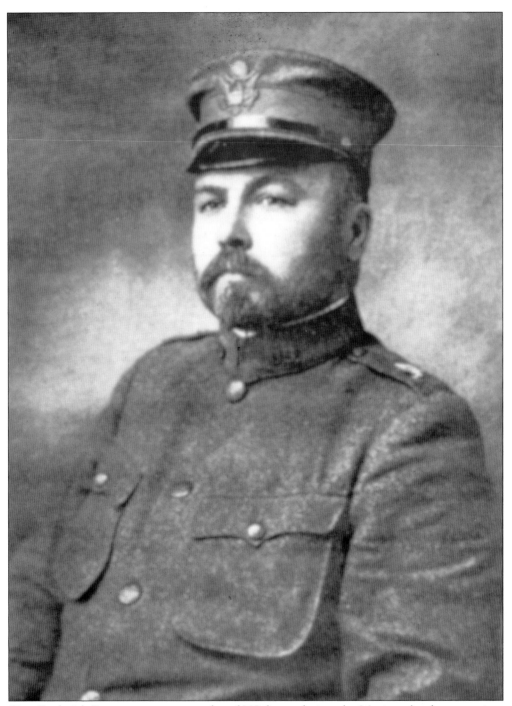

Gen. Frederick Funston was commander of US forces during the Mexican border campaign, overseeing Brig. Gen. John Pershing during his pursuit of Pancho Villa. In December 1916, General Funston ordered several Missouri units to go to Fort Riley, Kansas, where they were mustered out of federal service. Several months later, many of the soldiers who served on the border returned to Camp Clark to prepare for World War I service. (Jeremy P. Amick.)

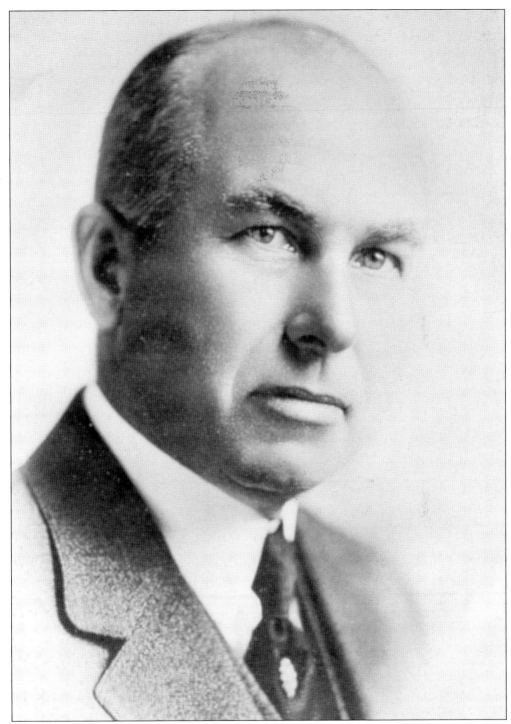

Frederick Dozier Gardner was inaugurated the 34th governor of Missouri on January 8, 1917. Several weeks later, the United States declared war against Germany, heralding the beginning of the country's involvement in World War I. In August 1917, Camp Clark became the site of the largest gathering of Missouri soldiers since the Civil War. (Jeremy P. Amick.)

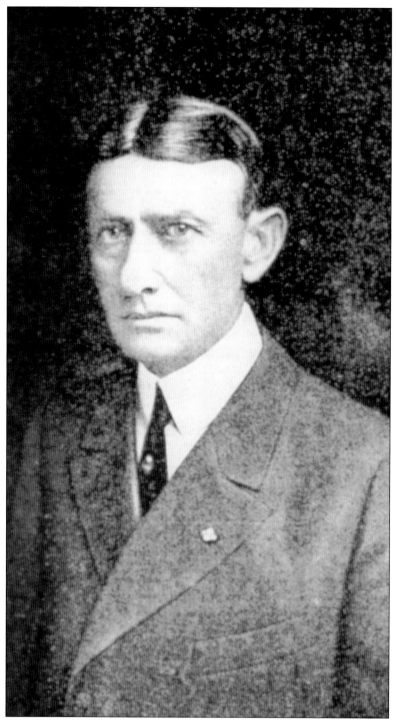

James H. McCord, a Missouri National Guard officer from St. Joseph, was appointed the adjutant general of the Missouri National Guard on May 28, 1917. He was given overall authority for enforcing the national military draft within Missouri in addition to organizing and equipping the Home Guard, who would help defend the state in the absence of its National Guard. (Jeremy P. Amick)

BRIGADIER GENERAL HARVEY C. CLARK

NATIONAL GUARD MISSOURI

On August 5, 1917, the entire National Guard was drafted into federal service for World War I, which included more than 14,000 troops from the Missouri National Guard. Brig. Gen. Harvey Clark was in charge of mobilization preparations at Camp Clark, where he was to receive the influx of the state's troops. Pictured is one of the general's business cards. (Museum of Missouri Military History.)

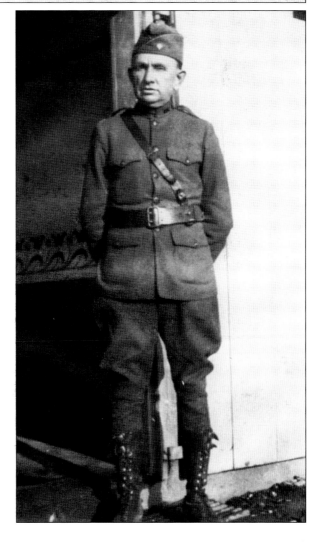

Prior to World War I, there were no engineer units in the Missouri National Guard. However, a battalion was assigned to Missouri and federalized for service in the war. Maj. E.M. Stayton, a civil engineer, helped organize the 110th Engineers. On August 16, 1917, the Missouri guardsmen traveled to the mobilization site at Camp Clark, where they conducted training for several days before moving to Camp Doniphan, Oklahoma, for further training. (Museum of Missouri Military History.)

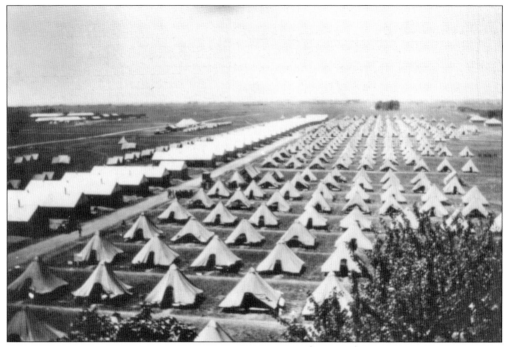

With more than 10,000 Missouri National Guard soldiers at Camp Clark training for service in World War I, there quickly appeared a veritable sea of light-colored tents erected alongside more permanent structures such as redbrick buildings. (Museum of Missouri Military History.)

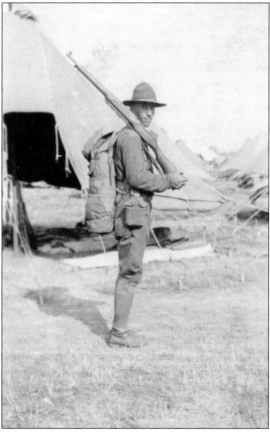

Carl Phenix of Poplar Bluff was inducted into Company M, 6th Infantry Regiment, of the Missouri National Guard on June 16, 1917. After the entire National Guard was mobilized several weeks later, the private first class began his training with the regiment at Camp Clark before being consolidated into the 140th Infantry and later deploying overseas. (Jeremy P. Amick.)

One of the most important components of the mobilization training received by the federalized Missouri National Guard companies at Camp Clark was marksmanship. They used the 100-yard and 1,000-yard ranges to refine their targeting skills. Pictured is the pit and the backstop for the rifle range in the 1930s. In October 1917, the camp grew in size with the acquisition of two tracts totaling 80 acres. Three months later, another 40-acre tract was purchased. (Museum of Missouri Military History.)

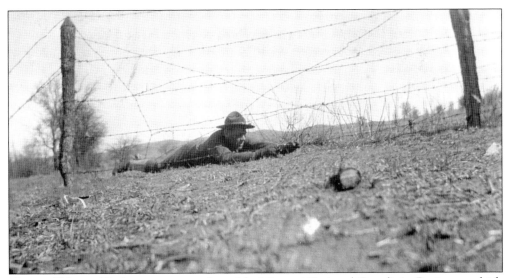

Vincent Kulage of St. Louis was a member of the Missouri National Guard's 1st Regiment, which traveled to Camp Clark after being federalized for World War I. Kulage, prior to deploying to France as a member of the consolidated 138th Infantry, received training on obstacle courses and in practice trenches at Camp Clark. (Jeremy P. Amick.)

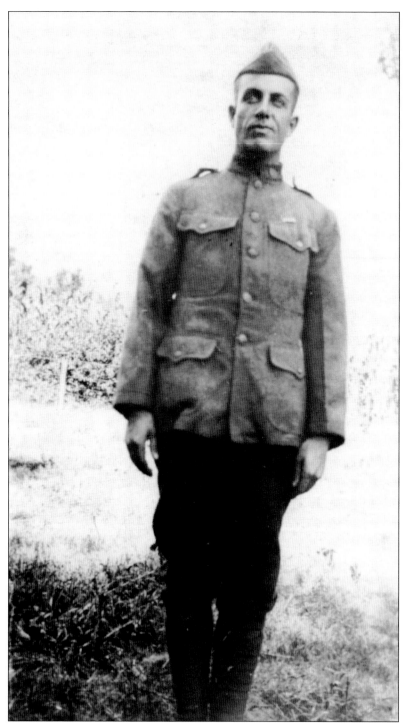

A native of Bradley, Missouri, Harry Davis was inducted into the Missouri National Guard as a member of Company E, 6th Infantry, on June 30, 1917. After the regiment was federalized, Private Davis received his initial training at Camp Clark before deploying to France. Sadly, he was killed in action during the Meuse-Argonne Offensive on September 28, 1918. (Jeremy P. Amick.)

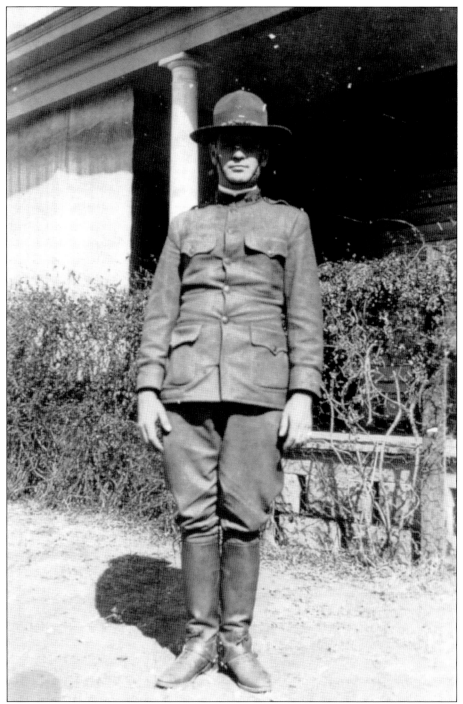

Louis Eoff Dettwiler was a veteran of the Mexican border campaign who had months earlier demobilized from federal service only to be called back. He was inducted as a lieutenant in Company A, 2nd Missouri Infantry, and assembled with the regiment at Camp Clark beginning August 17, 1917. The company became Company A, 128th Machine Gun Battalion, in October 1917, but Dettwiler was discharged prior to deployment because of a disability. (Jeremy P. Amick.)

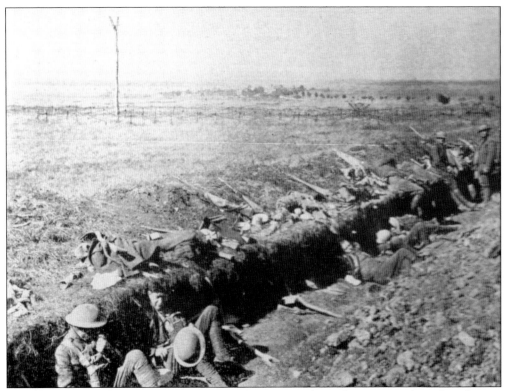

Trench warfare was a reality of combat on the western front of Europe. In an effort to prepare the Missouri National Guard mobilizing at Camp Clark in August 1917, practice trenches were dug. Pictured are soldiers of the 178th Infantry Brigade in France resting in trenches during the St. Mihiel Offensive; these were similar to the ones that many Missouri National Guardsmen used in combat. (Museum of Missouri Military History.)

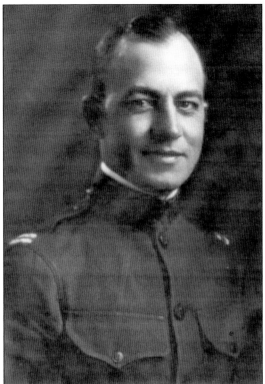

Capt. Alexander Skinker of St. Louis was federalized with the entire Missouri National Guard on August 5, 1917. Assigned to Company I, 138th Infantry, he trained at Camp Clark before the regiment transferred to Camp Doniphan on Fort Sill, Oklahoma, in late September 1917. Skinker was in command of his company when he was killed in France on September 26, 1918, while charging a machine-gun nest. He was posthumously awarded the Medal of Honor. (Jeremy P. Amick.)

Keeping the more than 10,000 Missouri soldiers mobilizing at Camp Clark fed was an onerous task. Cooks utilized clay ovens such as these to help bake for the guardsmen who were undergoing combat preparation training. (Museum of Missouri Military History.)

The *St. Louis Star and Times* reported on September 17, 1917, that not only was it critical to keep a growing military force fed on Camp Clark, but protecting their payroll was also a concern. As the article explained, Missouri National Guard soldiers helped guard the First National Bank of Nevada when $80,000 was received that was to be paid to the soldiers on Camp Clark. (Museum of Missouri Military History.)

CAMP CLARK PAY ROLL GUARDED BY TWENTY SOLDIERS

All Men at Nevada Probably Will Get Money by Wednesday Night.

By a Staff Correspondent of The Star.

CAMP CLARK, NEVADA, MO., Sept. 17.—A special guard around the First National Bank of Nevada gives evidence that "pay call" will blow today at Camp Clark. Saturday afternoon Capt. H. W. Bridges, camp quartermaster, collected $80,000 of the $290,000 needed to pay the soldiers here and it reposes in the First National. Twenty sentries guard the bank.

There will be three more shipments of money from Kansas City and Chicago between now and Wednesday, when it is expected the First Regiment, last in camp to be paid, will have drawn its money.

The money now in Nevada is sufficient to pay the Second and part of the Fourth regiments. The money is mostly in small bills. Officers will be paid by check, these having been mailed in Chicago Saturday.

Nevada, Missouri, native Leon Ogier trained at nearby Camp Clark during the summer of 1917 as a member of Company F, 4th Infantry Regiment of the Missouri National Guard. The 21-year-old private was serving overseas with the 128th Machine Gun Battalion when he was killed on October 29, 1918. His remains were returned to Nevada in June 1921 and interred in the city's Newton Burial Park. (Bushwhacker Museum.)

The American Legion Post 2 in Nevada was named in honor of Leon Ogier. The American Legion later moved into the Memorial Building, which had been built in 1910 as an armory for the Missouri National Guard. In November 1920, Col. Harry Mitchell, who was an early leader in the Missouri National Guard and who built the Hotel Mitchell in Nevada, presented the Leon Ogier Post 2 of the American Legion with a gavel. This gavel was made from wood taken from a tree that grew near the old Civil War internment site in Georgia known as the Andersonville Prison. (Jeremy P. Amick.)

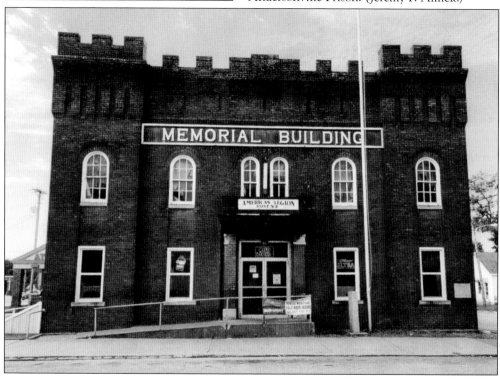

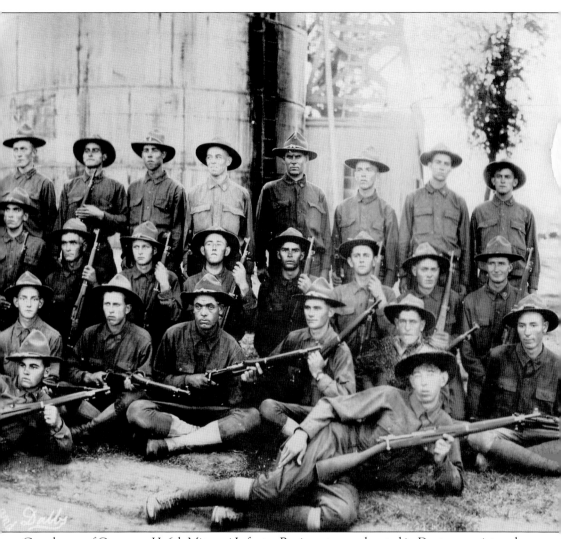

Guardsmen of Company H, 6th Missouri Infantry Regiment, once located in Dexter, are pictured in training at Camp Clark in August 1917. The 6th Infantry was later merged with the 3rd Missouri Infantry to form the 140th Infantry Regiment, which deployed to France. (Jeremy P. Amick.)

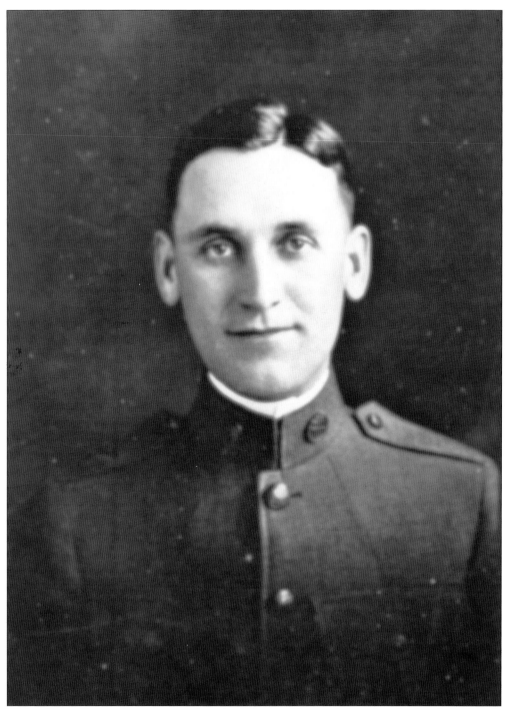

Walter Durnell served as a corporal in the Missouri National Guard under Lt. Col. Harvey Clark during the Spanish-American War. He received his commission as an officer with the 6th Missouri Infantry Regiment in 1917 and trained at Camp Clark. Captain Durnell was later transferred to a pioneer infantry regiment and remained stateside for the remainder of World War I. (Jeremy P. Amick.)

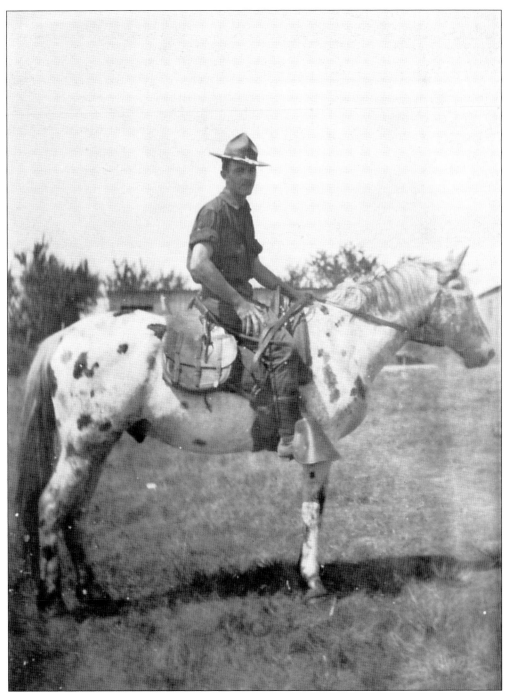

The Missouri National Guard's 7th Regiment, of Kansas City, was organized after the United States entered World War I and began a training encampment at Camp Clark on October 13, 1918. Since the war ended the following month, the regiment did not deploy overseas. Pictured is a member of the 7th Regiment during an encampment at Camp Clark in 1920. The 7th Regiment was later reorganized under the 3rd Infantry, which then changed to the 110th Engineers. (Jeremy P. Amick.)

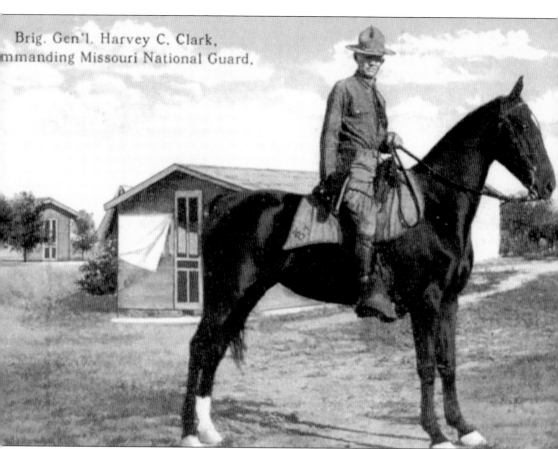

Brig. Gen'l. Harvey C. Clark,
mmanding Missouri National Guard.

While at Camp Doniphan with many of the federalized Missouri National Guard companies, Gen. Harvey Clark failed to pass the physical examination and was honorably discharged. Returning to Missouri, Governor Gardner appointed him adjutant general of the Missouri National Guard on January 1, 1918. General Clark was later recognized by the American Legion for his work to influence legislation that would be of benefit to returning Missouri troops. (Jeremy P. Amick.)

Three

GROWTH BEFORE WORLD WAR II

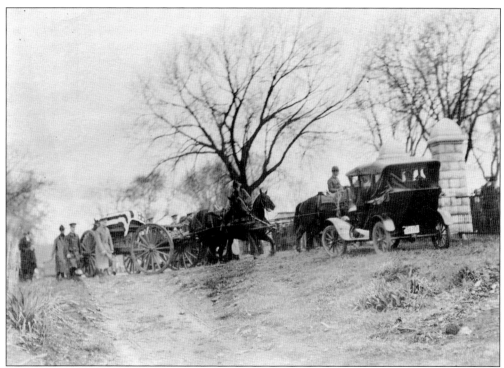

Gen. Harvey Clark served as the commanding general of the Missouri National Guard since 1899 in addition to fulfilling the role of state adjutant general from January 1918 to January 1921. The beloved general was 51 years old when he died from meningitis on April 11, 1921. Pictured is his flag-draped coffin being transported to his final resting spot in Oak Hill Cemetery in Butler. (Museum of Missouri Military History.)

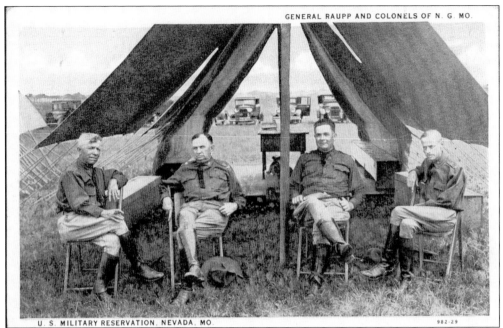

U. S. MILITARY RESERVATION, NEVADA, MO. 982-29

Gen. William A. Raupp, left, is pictured during an encampment at Camp Clark in the early 1920s. Raupp was appointed adjutant general of the Missouri National Guard on January 10, 1921, succeeding Gen. Harvey Clark. Shortly following General Clark's death in April 1921, the State Rifle Range was officially named Camp Clark in his honor. (Jeremy P. Amick.)

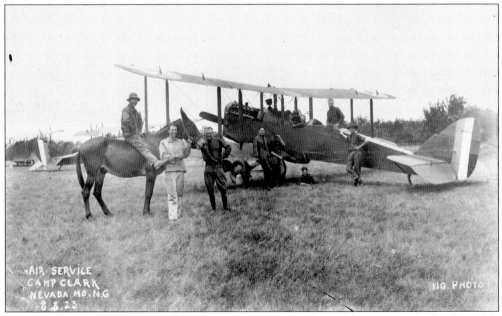

In the 1920s, training continued for the Missouri National Guard at Camp Clark. The 110th Observation Squadron of St. Louis, which later became part of the Missouri Air National Guard, flew its Curtiss JN-4s (known as a "Jenny" and used in World War I) to the grass-covered airstrip at Camp Clark. Pictured are members of the 110th at their first training encampment at the camp on August 5, 1923. (Museum of Missouri Military History.)

Three hundred Missouri National Guard soldiers of the 138th Infantry Regiment, of St. Louis, were accompanied to training at Camp Clark by 60 members of the 110th Observation Squadron in August 1925. One of the pilots who attended the camp was Capt. William Robertson, an aviation pioneer who served as the first commander of the 110th Observation Squadron when it received federal recognition in June 1923. (Museum of Missouri Military History.)

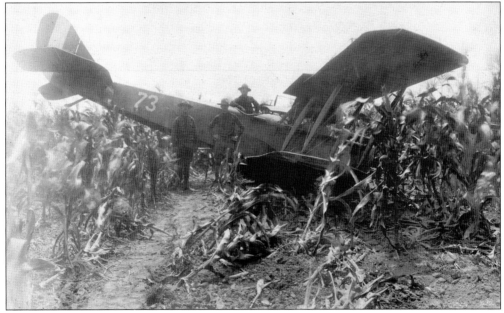

In August 1925, the 110th Observation Squadron arrived at Camp Clark with 10 of its Curtiss JN-4 aircraft, supplemented by 11 planes from Richards Field in Kansas City. On August 8, 1925, all 21 planes flew to Kansas City and returned to Camp Clark as part of training exercises. Training was not always without incident, as seen in this photograph in which an aircraft came to a stop in a cornfield near the airstrip. (Museum of Missouri Military History.)

HEADQUARTERS
MISSOURI NATIONAL GUARD
Pierce City

December 7 , 1926.

Subject: Assignment.

To: Lieutenant Charles A. Lindbergh, Air Service, Mo.N.G.,
 St. Louis, Mo.

These Headquarters having been notified that you have successfully
passed the examination for **First Lieutenant** , **Air Service** , you are
hereby notified that you have been assigned as **1st Lieutenant, 110th Obsv.Sqn.**,
35th Division Air Service , Missouri National Guard.

W. A. Raupp,
Brig.Gen., Mo.N.G.,
Commanding.

RECD. A. G. O. MO. JAN 7

This letter, signed by Gen. William Raupp, serves as the appointment of Charles Lindbergh as a
lieutenant in the 110th Observation Squadron as of December 7, 1926. In an interview conducted
decades ago by the Museum of Missouri Military History, Bill Whistler recalled that Lindbergh
landed his airplane at Camp Clark sometime prior to his famed transatlantic flight and gave rides
to passengers for $2.50. (Museum of Missouri Military History.)

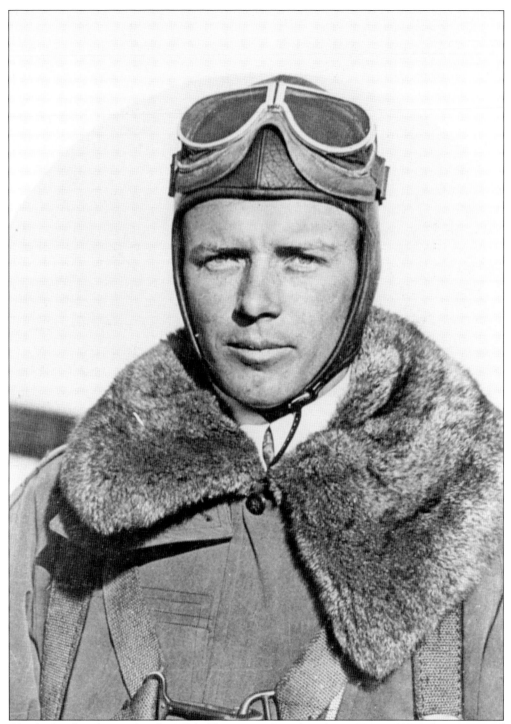

Charles Lindbergh served in the 110th Observation Squadron from 1924 to 1927 and accompanied the squadron to Camp Clark for training in 1924 and 1925. He achieved worldwide fame in 1927 for his nonstop solo flight of more than 33 hours across the Atlantic Ocean in his aircraft *Spirit of St. Louis*. (Museum of Missouri Military History.)

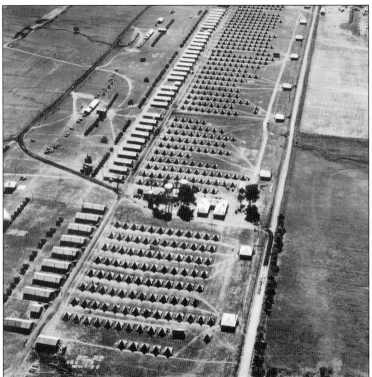

This aerial photograph shows the layout of buildings and tents on Camp Clark during an encampment in the late 1930s. The camp had grown in size to 643.4 acres by 1929 and was one-half mile wide and two miles long. The size of the camp doubled in May 1929 with the acquisition of an additional 643.6 acres, now the northern part of the camp. Additionally, electricity came to the camp in 1928. (Museum of Missouri Military History.)

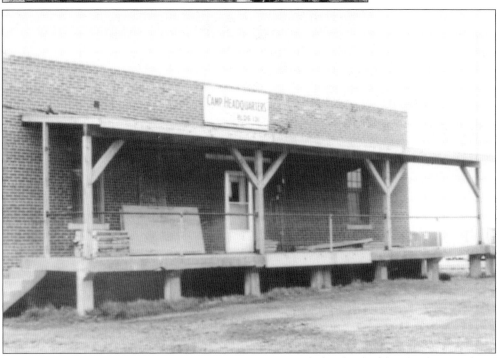

Pictured is Building 131, the camp headquarters for Camp Clark. This building has been updated in recent decades and is still used as the headquarters and training center command for the camp. (Museum of Missouri Military History.)

Fred Graf of Warrensburg is pictured at Camp Clark in 1926 while training with the 35th Infantry Division. The soldier later served during both World War II and the Korean War, attaining the rank of master sergeant. (Jeremy P. Amick.)

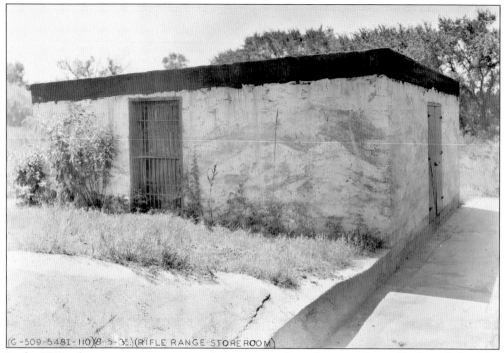

In the 1920s, there were many construction projects taking shape on Camp Clark, including the erection of this concrete structure as a storeroom for the rifle range. At the time, the rifle range consisted of 30 targets. (Museum of Missouri Military History.)

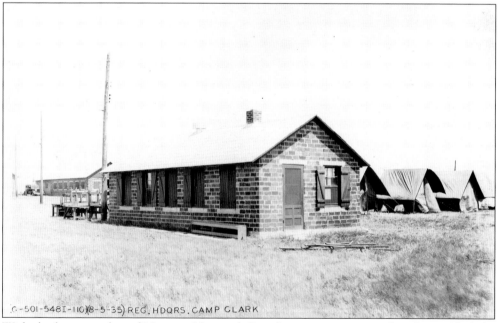

With the large number of Missouri National Guard troops concentrated at Camp Clark for encampments, many buildings were erected after World War I to accommodate training needs. This redbrick building was used as a regimental headquarters during encampments. (Museum of Missouri Military History.)

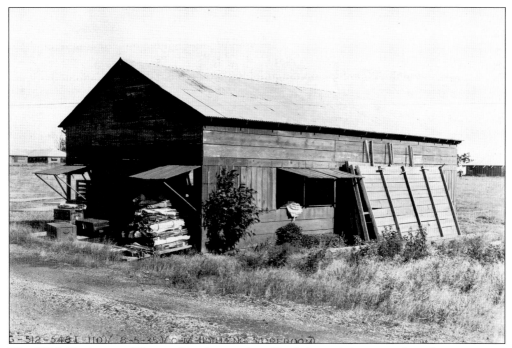

The 110th Engineers of Kansas City frequently utilized the training grounds and target ranges on Camp Clark in the years following World War I. Pictured is one of the buildings they used to store equipment for their encampments. (Museum of Missouri Military History.)

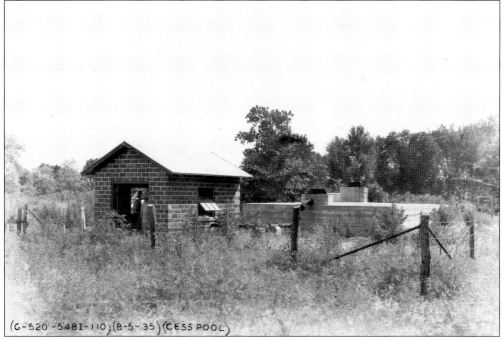

As part of the planning for the massive influx of troops, adequate sewage facilities were constructed in the late 1920s. The estimated cost for the sewer system was $17,065.25, while the disposal plant, pictured, was estimated to be $5,065. (Museum of Missouri Military History.)

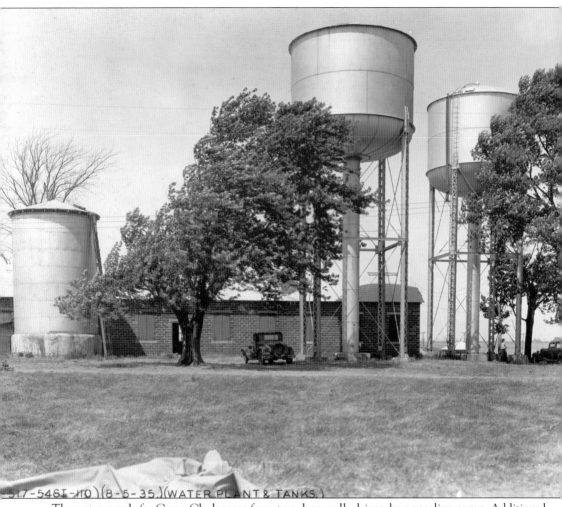

-517-5481-110 (8-5-35.)(WATER PLANT & TANKS.)

The water supply for Camp Clark came from two deep wells driven by a gasoline pump. Additional water came from a line that ran three miles from the city of Nevada to Camp Clark, which was laid in the fall of 1917. Each company training on post was provided a hydrant from which it drew its water. (Museum of Missouri Military History.)

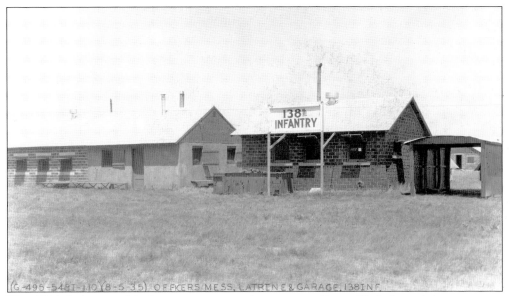

(G-495-5481-110)(8-5-35) OFFICERS MESS, LATRINE & GARAGE, 138 INF.

The 138th Infantry, of St. Louis, was assigned an area on Camp Clark for training purposes. Pictured are the officers' mess hall, a latrine, and a small garage for company wagons. There were large barns on post to house the horses that pulled wagons in the years before the widespread use of automobiles. (Museum of Missouri Military History.)

Although Camp Clark began to acquire many conveniences such as running water in its early years, primitive privies, such as this one pictured on the rifle range, were used by the soldiers when away from the cantonment areas. (Museum of Missouri Military History.)

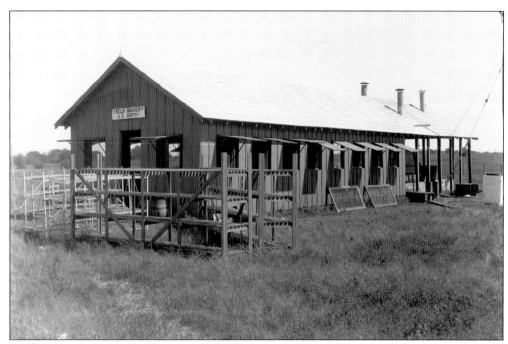

In 1929, there were many improvements and additions to Camp Clark. One of these was a bakery building that measured 16 by 40 feet with a 14-foot extension over the ovens. (Museum of Missouri Military History.)

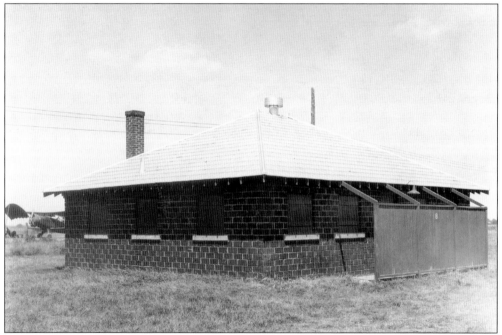

Pictured is the bathhouse that was used by the 35th Division Air Service during an encampment at Camp Clark. In the late 1920s, five bathhouses were added at the camp, and it was a general practice that each battalion would be given one bathhouse for its use during training. (Museum of Missouri Military History.)

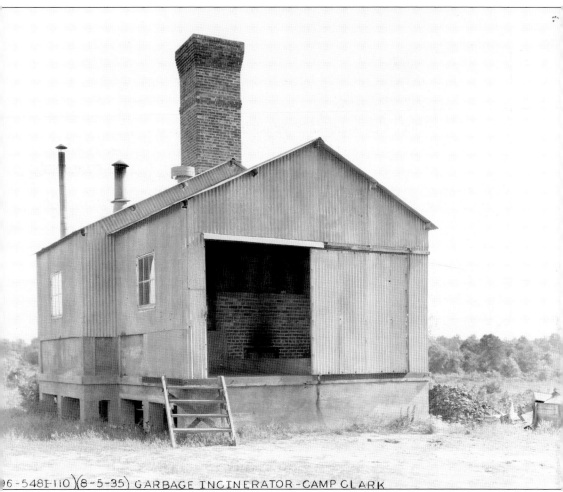

96-548I-110 (8-5-35) GARBAGE INCINERATOR - CAMP CLARK

The trash that was produced when large concentrations of troops trained at the post became a concern to military planners. They erected this incinerator on the camp in the late 1920s to dispose of the refuse. (Museum of Missouri Military History.)

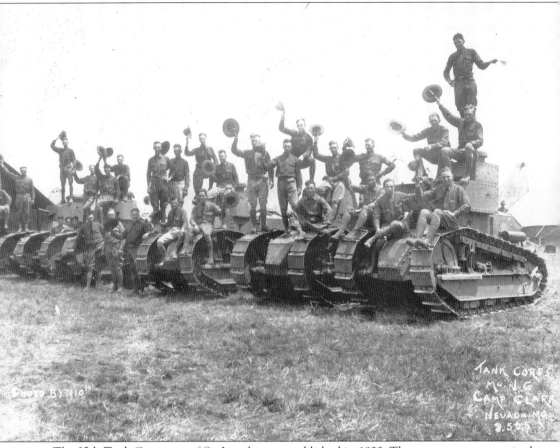

The 35th Tank Company, of St. Joseph, was established in 1923. The company was recruited to full strength of 105 soldiers and 5 commissioned officers by early 1925. Several months later, in August 1925, the company traveled to Camp Clark with its tanks to participate in an annual encampment of the Missouri National Guard. (Museum of Missouri Military History.)

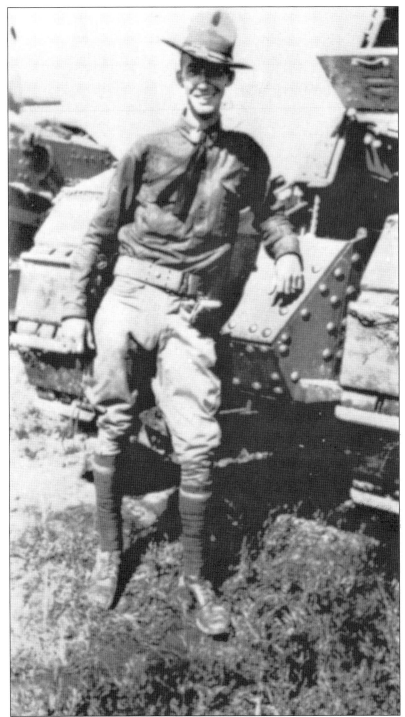

For the first five decades of its existence, Camp Clark was used for weekend marksmanship training and tank training, and it also had an organizational maintenance shop for tanks. Pictured is a member of the 35th Tank Company leaning against a tank during the annual encampment at Camp Clark in the summer of 1925. (Museum of Missouri Military History.)

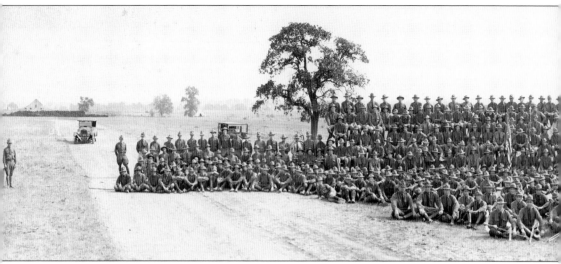

The 140th Infantry Regiment Band, from Chaffee, Missouri, is pictured at Camp Clark in August 1926 during its annual encampment. The band's activities and training at Camp Clark were captured through photographs taken and preserved by O.T. Honey, who served for many years as the band's director. (O.T. Honey Collection, Missouri State Archives.)

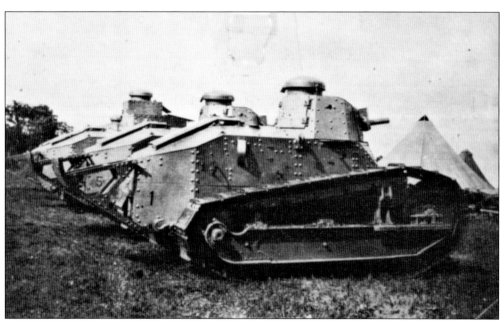

The 35th Tank Company joined infantry, engineers, and the observation squadron of the Missouri National Guard at Camp Clark in August 1926 for its annual encampment. During the training, the tank company used World War I–era tanks. (Museum of Missouri Military History.)

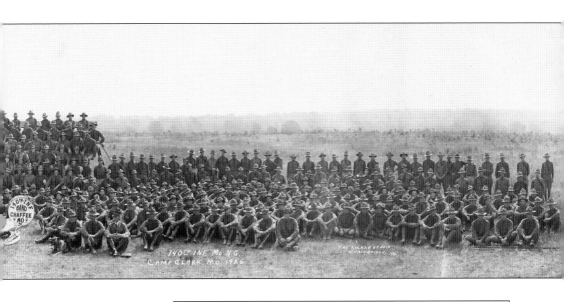

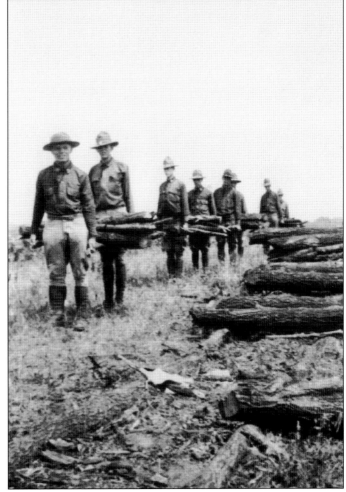

In May 1926, a group of 350 cadets from Kemper Military School in Boonville spent four days at Camp Clark. Several months later, in August 1926, Missouri National Guard soldiers spent two weeks at the camp. Pictured are the guardsmen carrying wood to be used in open-pit cooking during their encampment. (Museum of Missouri Military History.)

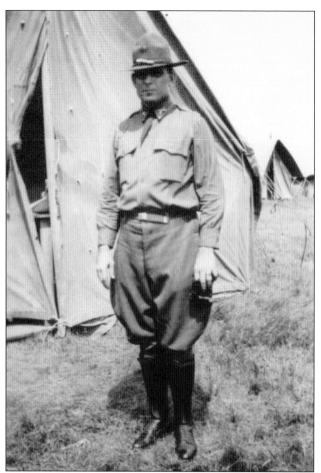

Fred Byron House, of Knob Noster, Missouri, was inducted into the US Navy and served aboard the USS *Utah* during World War I. He later joined the Missouri National Guard and rose to the rank of colonel. He is pictured at an encampment at Camp Clark while assigned to the 35th Infantry Division. (Jeremy P. Amick.)

A squad of soldiers assigned to the Missouri National Guard's 140th Infantry Regiment is pictured resting on cots outside their tent during an encampment held at Camp Clark in August 1928. (O.T. Honey Collection, Missouri State Archives.)

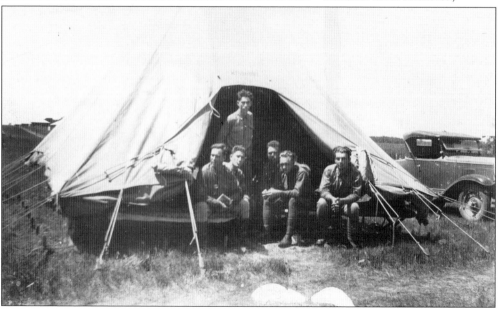

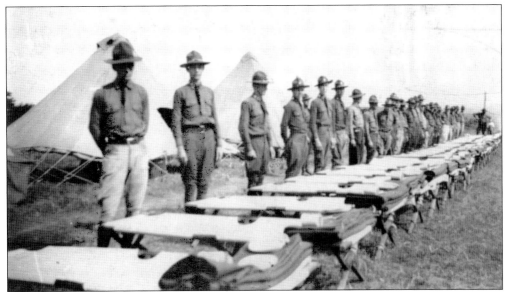

Soldiers of the 140th Infantry Regiment wait by their cots during an inspection at their annual encampment at Camp Clark on August 17, 1929. An estimated 3,000 Missouri National Guard troops, under the command of Gen. William Raupp, attended the two-week encampment. (O.T. Honey Collection, Missouri State Archives.)

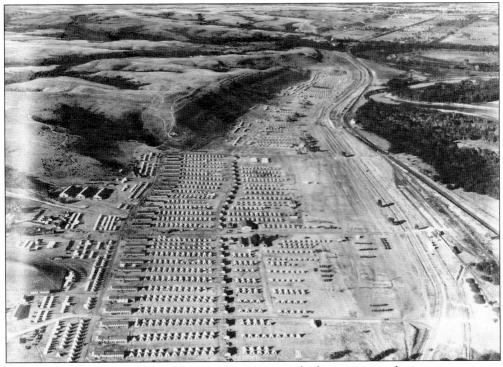

Tents in rows erected closely together were a common sight for many years during encampments at Camp Clark. In 1929, the camp again nearly doubled in size with the purchase of an additional 640 acres, resulting in the current total acreage of 1,287. (Museum of Missouri Military History.)

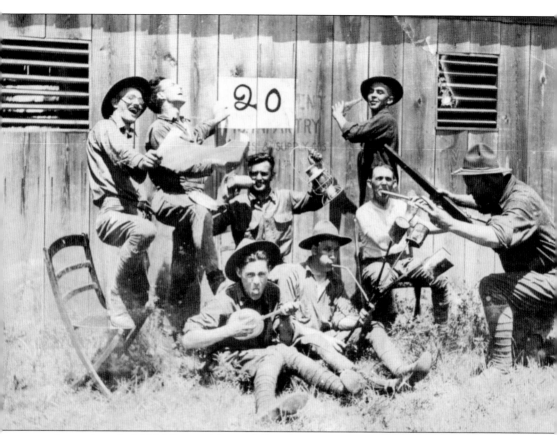

Approximately 2,000 Missouri National Guard troops were encamped at Camp Clark in August 1930, which included the 140th Infantry Regiment under the command of Col. George Phipps of Caruthersville. Pictured is a "junk band" directed by O.T. Honey, far right, who was chief musician of the 140th Infantry Regiment Band. (O.T. Honey Collection, Missouri State Archives.)

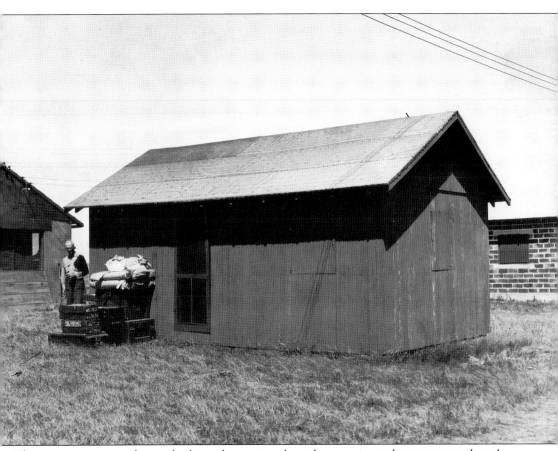

There were many storehouses built on the post, such as the one pictured, to accommodate the storage needs of supply officers of the companies that were training at Camp Clark. (Museum of Missouri Military History.)

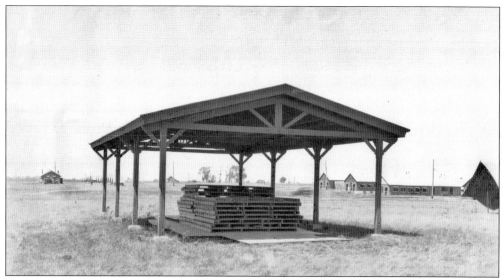

To afford the Missouri National Guard soldiers in training at Camp Clark an opportunity to attend worship services, a pavilion was constructed. A chapel would not be erected on the camp until more than six decades later. (Museum of Missouri Military History.)

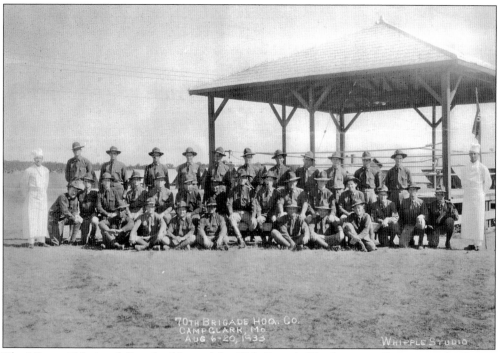

The Missouri National Guard soldiers of the 70th Brigade Headquarters Company, of Jefferson City, were among more than 2,500 who were in training at Camp Clark in August 1933. (Museum of Missouri Military History.)

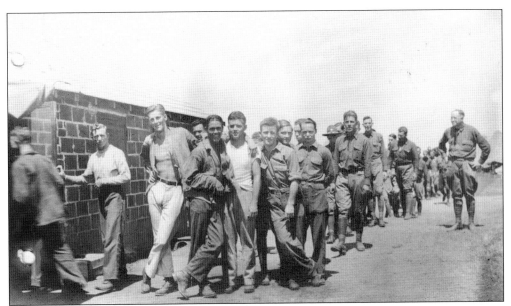

Soldiers of the 140th Infantry Regiment pause for a photograph during the annual encampment at Camp Clark in 1933. Gen. Edward Stayton, commander of the 110th Engineers, who were also attending the encampment, said of Camp Clark, "I think it is one of the finest military reservations in the country and I am going to do everything I can to make it the best." (O.T. Honey Collection, Missouri State Archives.)

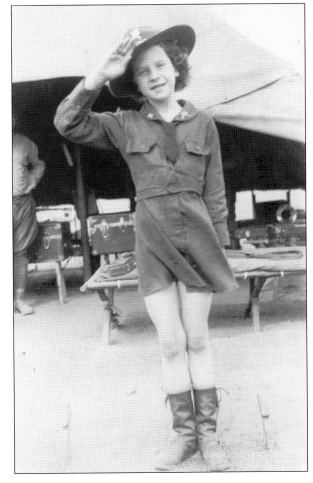

A young Carol Jean Graves is pictured in August 1935 while at Camp Clark with the 140th Infantry Regiment. Graves traveled with the regiment to its encampments between 1933 and 1935, conducting performances as a guest singer. For her efforts, Missouri governor Guy Park presented her an honorary commission as a colonel in 1935. (O.T. Honey Collection, Missouri State Archives.)

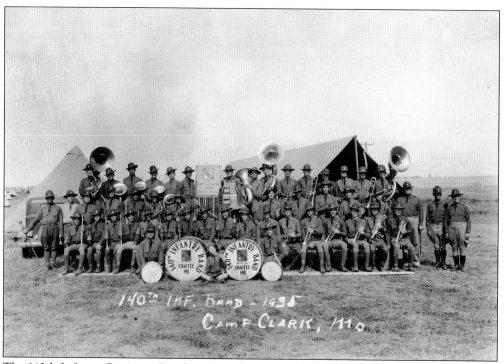

The 140th Infantry Regiment Band performed a concert for its fellow Missouri National Guard soldiers, in addition to Gov. Guy Park, while participating in the regiment's summer encampment at Camp Clark in 1935. (O.T. Honey Collection, Missouri State Archives.)

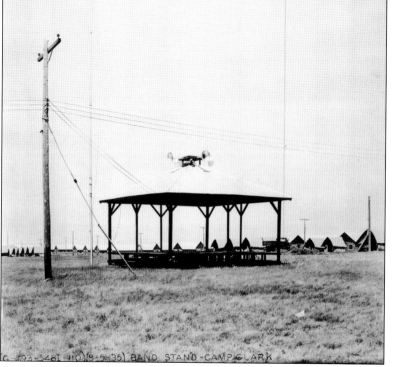

A bandstand once stood on the parade field at Camp Clark for performances to entertain the troops. In August 1935, it was used by Gov. Guy Park, in his position as the state's commander-in-chief, to review three large regiments of the Missouri National Guard. (Museum of Missouri Military History.)

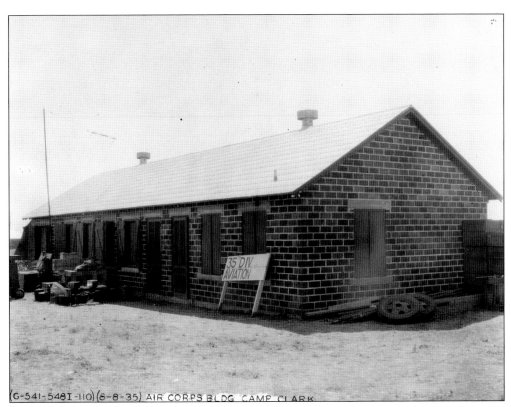

(G-541-548I-110) (8-8-35) AIR CORPS BLDG CAMP CLARK

Due to flooding at Fort Riley, Kansas, the 35th Aviation Division of the Missouri National Guard moved its annual training to Camp Clark in August 1935. At the time, the division consisted of 20 officers and 95 enlisted soldiers and had seven US Army airplanes to use during its encampment. Pictured is one of the buildings the division assigned for storage during its training period. (Museum of Missouri Military History.)

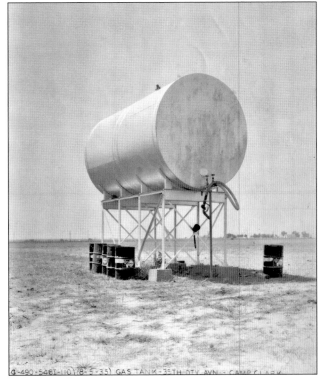

The 35th Aviation Division, under the command of Maj. Phillip Love, began its two-week training at Camp Clark on August 4, 1935. While there, it utilized this tank for fuel storage for the aircraft assigned to its pilots and crews. (Museum of Missouri Military History.)

G-490-548I-110 (8-5-35) GAS TANK - 35TH DIV AVN - CAMP CLARK

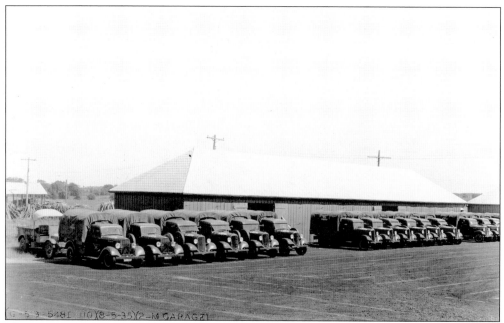

The companies training at Camp Clark had garages available to store and work on their assorted vehicles. In 1929, six years prior to this photograph, five "motor barns" were erected on the camp—two measured 25 feet by 150 feet, two measured 25 feet by 162 feet, and one measured 26 feet by 125 feet. (Museum of Missouri Military History.)

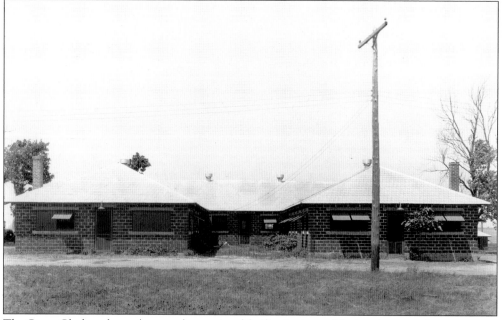

The Camp Clark exchange/canteen/recreational facility is pictured during the annual encampment of the Missouri National Guard in 1929. The building was constructed in 1929 and measured 28 feet by 76 feet. In May 1929, a $70,000 appropriation was received from the federal government that allowed for additional land purchases and improvements to be made to the camp. (Museum of Missouri Military History.)

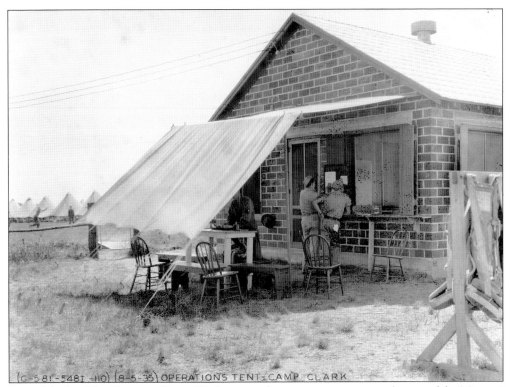

(G-581-5481-HO) (8-5-35) OPERATIONS TENT. CAMP CLARK

One of the brick buildings on Camp Clark was used as an operations center by one of the Missouri National Guard units during their annual encampment in August 1935. Sen. Harry S. Truman visited Camp Clark during the encampment and reportedly praised the officers for the camp's clean and orderly appearance. (Museum of Missouri Military History.)

Through labor that was supplied by the Public Works Administration—a construction agency created during the Great Depression—many projects and improvements were completed on Camp Clark. Those included the construction of this large, native stone gateway entrance to the camp. (Museum of Missouri Military History.)

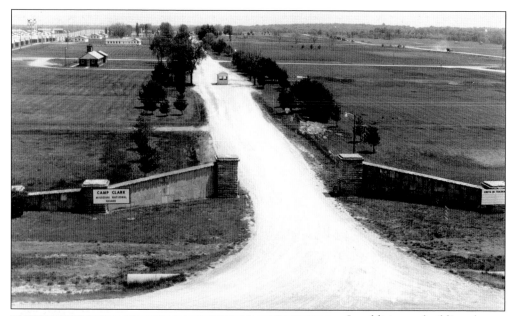

In addition to building the stone entrance to the camp, which is still in use today, labor and funds under public works programs included improvements completed in 1937 such as construction of the backstop for the rifle range, enlargement of a lake, and an extension to the camp headquarters building. (Museum of Missouri Military History.)

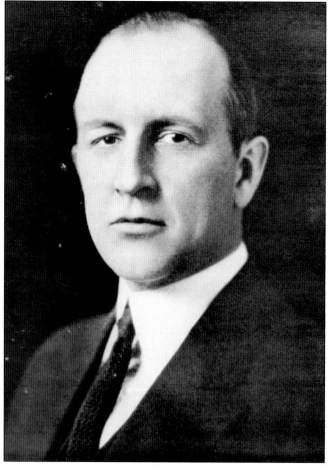

The annual encampments of the Missouri National Guard remained an event often warranting a visit from the governor and other dignitaries. On August 25, 1939, Governor's Day was held at Camp Clark, during which Gov. Lloyd C. Stark reviewed the Missouri soldiers. (Jeremy P. Amick.)

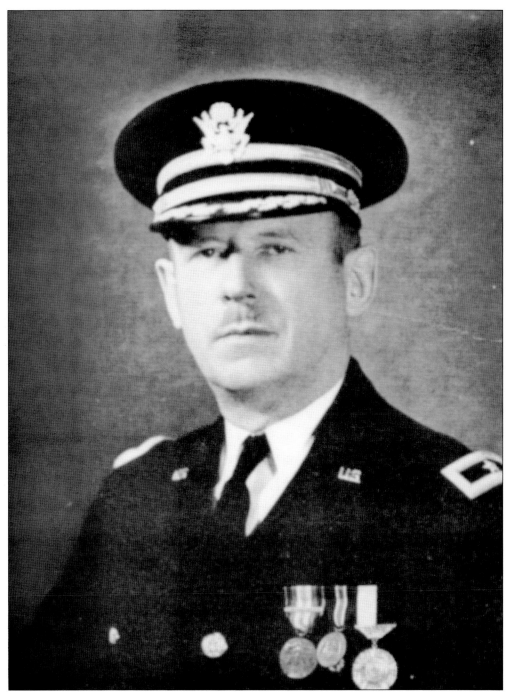

Pictured is Lewis M. Means, adjutant general of the Missouri National Guard, who attended the annual encampment in 1939. General Means invited fellow World War I veteran Maj. Gen. (retired) E.M. Stayton to the training to review the soldiers of the 110th Engineers, which Stayton formerly served as commanding officer. (Jeremy P. Amick.)

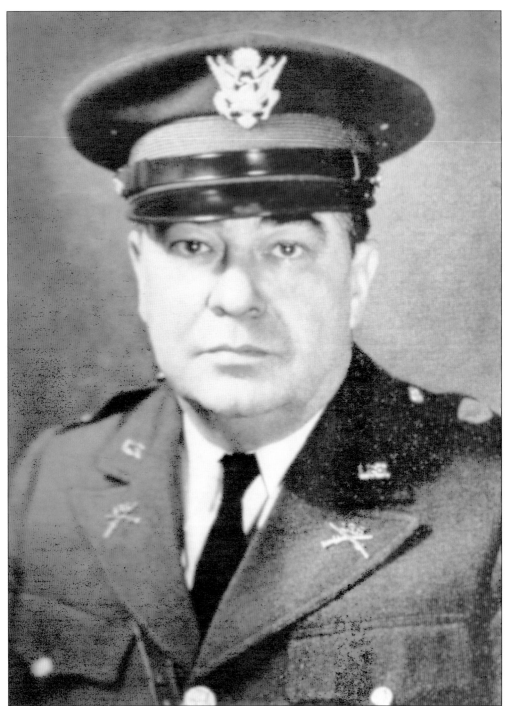

Col. Lawrence C. Kingsland was commanding officer of the 138th Infantry Regiment, of St. Louis, during the 1939 encampment at Camp Clark. A 1908 graduate of Washington University, Kingsland became a nationally known patent attorney and later served in many impressive roles, including commissioner of patents in the Truman administration from 1947 to 1949 and legal adviser to the Philippines government on patents. (Jeremy P. Amick.)

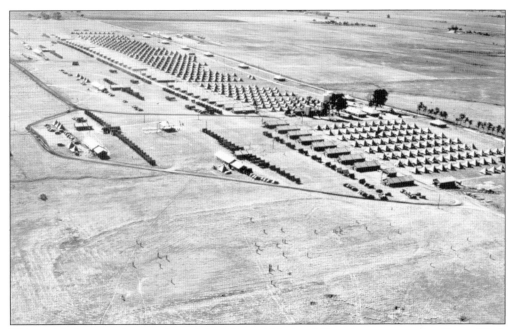

This aerial photograph was taken of the Missouri National Guard encampment at Camp Clark in August 1935. Nearly 2,500 soldiers from infantry, engineer, tank, and command units were in attendance for the two-week training. Much of the training of the state's troops was provided by US Army instructors. (Museum of Missouri Military History.)

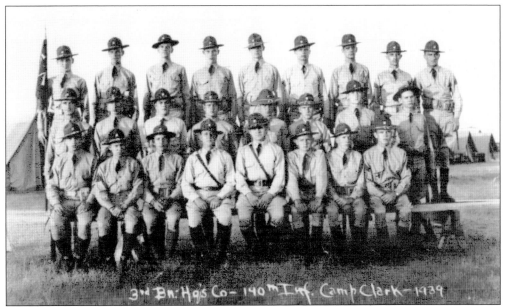

Soldiers from Headquarters Company, 3rd Battalion, 140th Infantry Regiment, pose for a photograph during their annual training at Camp Clark in August 1939. Several weeks later, as war was unfolding in Europe, the regiment began recruitment efforts for an additional 210 soldiers following an executive order by Pres. Franklin Roosevelt calling for an increase in the enlisted strength of the entire National Guard to 235,000. (Bushwhacker Museum.)

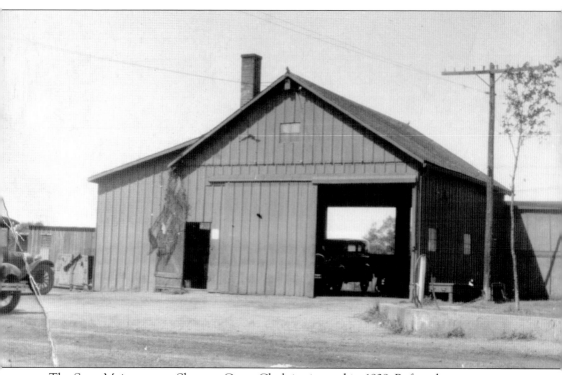

The State Maintenance Shop on Camp Clark is pictured in 1939. Referred to as a motor repair shop when it was erected in 1929, the shop was used to repair and maintain vehicles owned by the Missouri National Guard and its subordinate units and initially measured 30 feet by 35 feet. (Museum of Missouri Military History.)

Four

WORLD WAR II AND PRISONERS OF WAR

In early 1941, prior to the US entry into World War II, Bennett Champ Clark, a US senator for Missouri who had served with the Missouri National Guard in World War I, lobbied for the expansion and development of Camp Clark. Initial efforts were made to have the camp established as an Air Corps installation, but these attempts failed. (Museum of Missouri Military History.)

Sen. Harry S. Truman, also a Missouri National Guard veteran who served in World War I, was an advocate for increased usage of Camp Clark in World War II. Representatives from Nevada visited with Truman to encourage him to work with the War Department in converting Camp Clark into a US Army training location similar to the one being built near St. Robert that became Fort Leonard Wood. (Museum of Missouri Military History.)

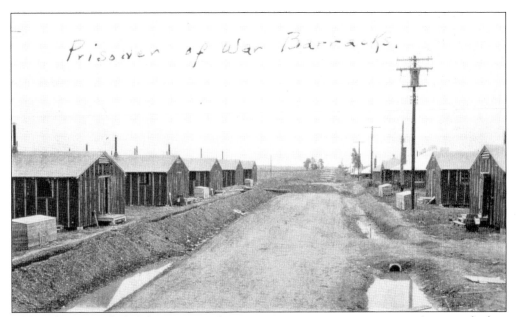

Although Camp Clark did not possess the acreage to warrant a major wartime training facility, its remote location, along with its access to a spur of the Missouri Pacific Railroad, resulted in its selection as the site of a prisoner of war camp. In May 1942, the War Department announced it was allocating $2.5 million to build an internment camp at Nevada. Pictured are barracks that were erected in an area on Camp Clark that housed prisoners of war. (Bushwhacker Museum.)

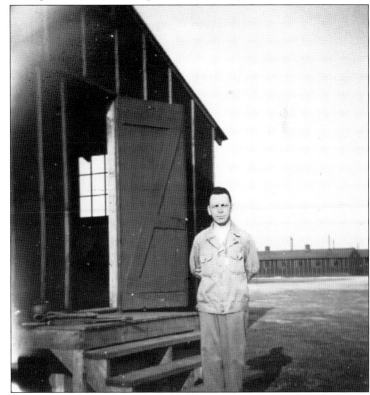

Activation proceedings for Camp Clark as a prisoner of war camp occurred from August 3 to September 5, 1942. During its use as a POW camp, there were a total of 282 buildings on the camp, 163 of which were inside the POW compound. Pictured is a young Lauren S. Frisbee, an enlisted soldier assigned to the 358th Military Police Escort Guard Company, standing outside one of the buildings on post in late 1942. (Jeremy P. Amick.)

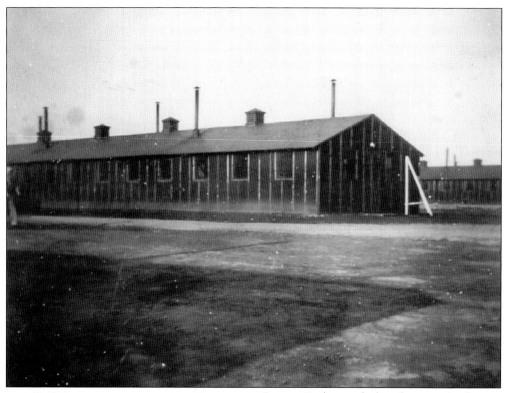

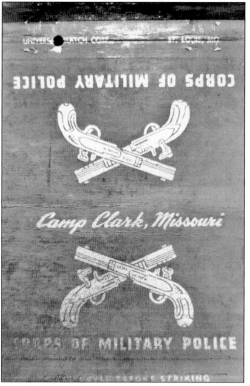

Lauren Frisbee took this photograph of the mess hall used by his military police company while he was stationed at Camp Clark to guard prisoners of war during World War II. The first military police company arrived from Camp Forrest, Tennessee, on September 7, 1942, with an additional nine military police companies reporting to camp five weeks later. (Jeremy P. Amick.)

As Camp Clark began to grow as a result of its new mission as a POW camp, new buildings were erected to support both the military police contingent and the POWs. A 150-bed station hospital was built in addition to a post theater. Pictured is the cover of a matchbook that would have been sold at the new post exchange, which opened on September 8, 1942. (Jeremy P. Amick.)

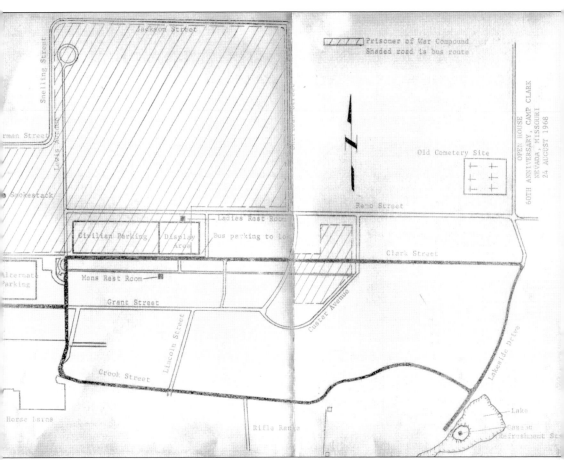

This map from an open house at Camp Clark in 1968 shows the location of the prisoner of war compound on the northern section of the camp. The War Department awarded the building contract for the erection of the POW camp to McCarthy Brothers Construction Company of St. Louis; this same company was awarded the contract to build the internment camp at Fort Leonard Wood. (Museum of Missouri Military History.)

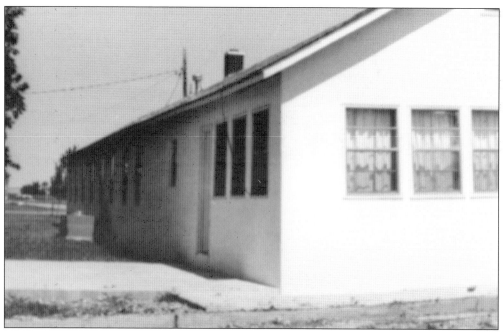

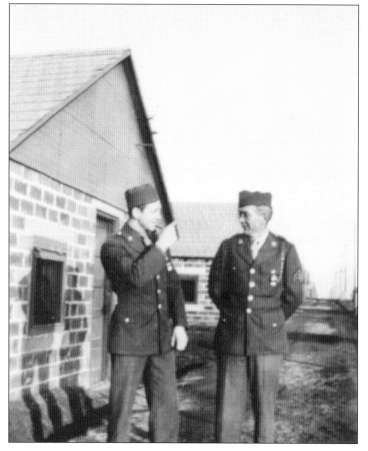

The construction contract awarded to McCarthy Brothers Construction for Camp Clark not only included such buildings as barracks and mess halls similar to the one pictured but also fencing and guard towers for the internment areas. (Museum of Missouri Military History.)

Old seemed to meet new when the military police companies began to arrive at the camp to prepare and train for the coming of the POWs. Although construction of newer buildings for accommodations on the camp continued, many of the older buildings erected in the 1920s and 1930s, including the red clay tile ones pictured, were utilized. (Bushwhacker Museum.)

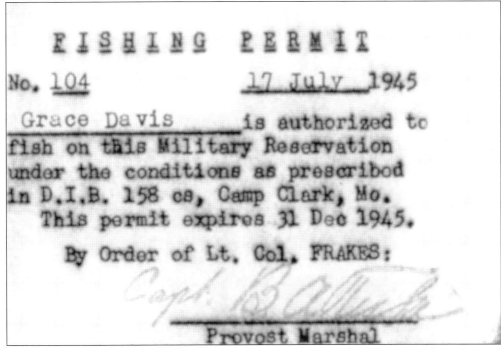

Civilian Employees Identification Card

Camp Clark, Missouri

Name of employee: Grace G. Davis

Address: 315 W. Hickory, City Nevada.

Race	Color of Eyes	Weight	Color of Hair
W	Brown	172	Dk. Brown

Date Birth	Sex	Height	Citizenship (Check)
/12/02	F	5'4½"	By Birth X Naturalized Alien

By Whom Employed: Post Exchange Service

Signature (Employee): Grace G. Davis

Signature (Issuing Officer): John M. Kent 1st Lt Camp P.M.

12-74-3 Card to be turned in on termination of employment

As soldiers poured into the camp and new buildings were erected, many local civilians were hired to work in varying capacities. Pictured is an identification card for Nevada resident Grace Davis, who was employed in the new post exchange on Camp Clark. (Bushwhacker Museum.)

FISHING PERMIT

No. 104 17 July 1945

Grace Davis is authorized to fish on this Military Reservation under the conditions as prescribed in D.I.B. 158 cs, Camp Clark, Mo.
 This permit expires 31 Dec 1945.

 By Order of Lt. Col. FRAKES:

Capt. _____
 Provost Marshal

Civilians and military personnel were given opportunities to take advantage of recreational resources available on Camp Clark. This fishing permit was issued to Grace Davis and granted her permission to fish in the South Lake on the camp. (Bushwhacker Museum.)

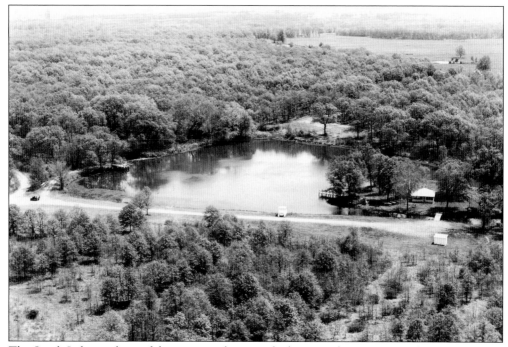

The South Lake is a beautiful recreational area tucked among the training and maneuver areas on Camp Clark. There is a small island on the lake where a pavilion was built, which became a location for dances, barbecues, and other recreational events enjoyed by soldiers and local residents during World War II and beyond. Approximately 30 years later, the North Lake was built on the camp. (Museum of Missouri Military History.)

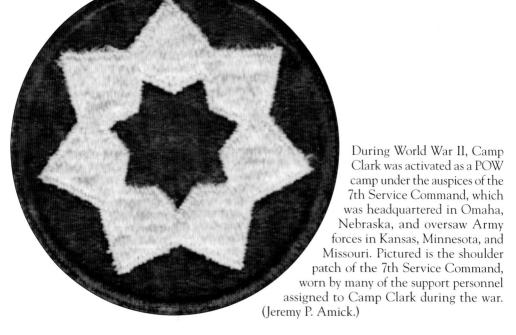

During World War II, Camp Clark was activated as a POW camp under the auspices of the 7th Service Command, which was headquartered in Omaha, Nebraska, and oversaw Army forces in Kansas, Minnesota, and Missouri. Pictured is the shoulder patch of the 7th Service Command, worn by many of the support personnel assigned to Camp Clark during the war. (Jeremy P. Amick.)

Cottey College is a private women's college founded in Nevada in 1884. During World War II, the Cottey Community Theater, which was organized around 1939, held plays at the college auditorium. Although many of the parts in the plays were filled by women attending the college, many of the male roles were played by soldiers serving at Camp Clark. Pictured is the main hall of Cottey College. (Jeremy P. Amick.)

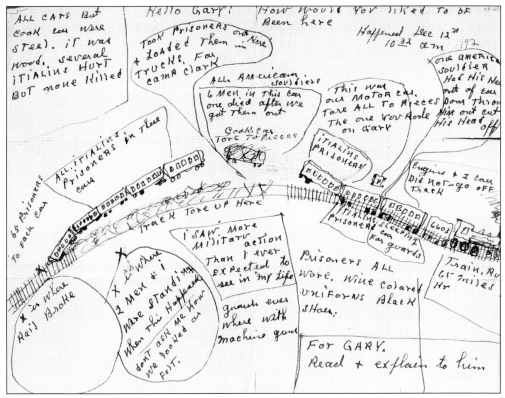

Tragedy struck on December 12, 1942, as MP companies prepared to receive a troop train carrying around 350 Italian prisoners of war. The train wrecked nearly seven miles north of Nevada, injuring several POWs and military policemen, while two MPs were killed in the incident. This hand-drawn map was made by a witness at the scene to detail the accident. (Bushwhacker Museum.)

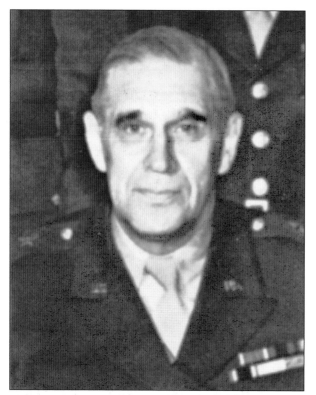

In late December 1942, Maj. Gen. Frederick Uhl, who was serving as the commanding general of the 7th Service Command, sent a commendation letter to the staff at Camp Clark. In it, he praised the officers and enlisted soldiers for the excellent manner in which they handled themselves during the emergency response to the derailment of the train transporting prisoners of war. (Museum of Missouri Military History.)

Capt. Arthur E. Pratt was one of the early arrivals at Camp Clark after it was designated a POW camp. Assigned to the 7th Service Command, Pratt served as camp adjutant. In this capacity, he assisted his commanding officer, Maj. Paul Lamb, with various aspects of administration, including the establishment of a recreational and athletic program for the soldiers on post. (Bushwhacker Museum.)

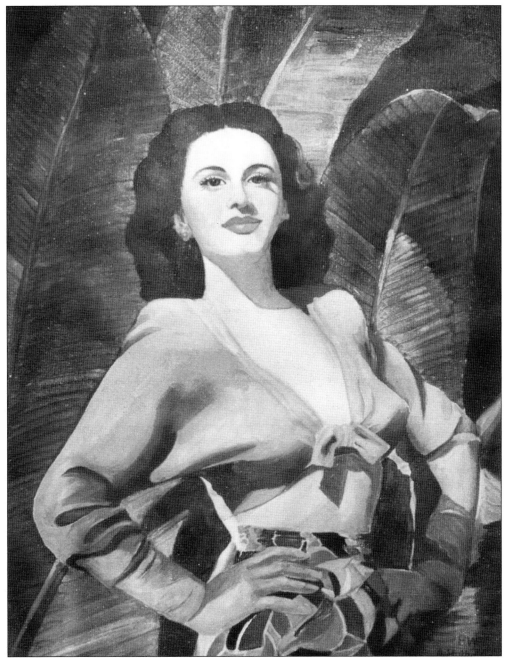

For the remainder of the war, Capt. Arthur Pratt remained assigned to Camp Clark. Many of the POWs under guard by the military policemen on post pursued recreational activities such as painting during their free time. Captain Pratt purchased from a German POW this painting of Hedy Lamarr, a popular Austrian-born American film actress and inventor. (Bushwhacker Museum.)

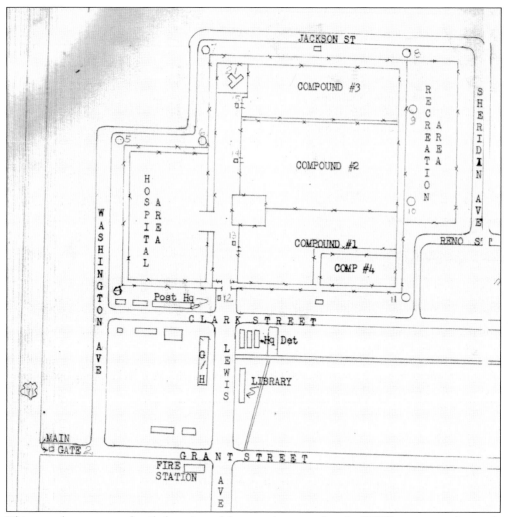

This map shows a more detailed version of the area that served as the POW section on the north side of Camp Clark during World War II. The compounds were located behind two fences, the inside of which was constructed of barbed wire strung on six-inch-by-six-inch posts. The exterior fencing was made from hog wire and was 12 feet from the interior fence. There was a road running around the entire compound used by military police who patrolled it on horseback. (Museum of Missouri Military History.)

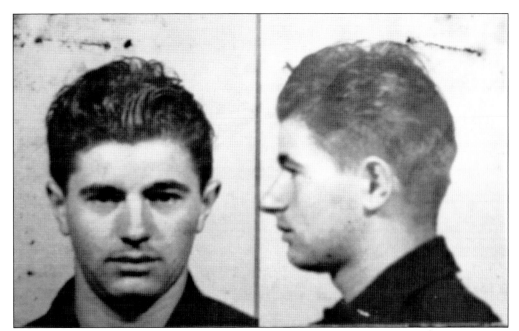

Italian prisoners of war were the first to arrive at Camp Clark. This photograph of Gino Parise was taken for his ID shortly after his in-processing at the camp. There were instances of turmoil within the POW population, one of which unfolded in the early weeks of 1944 and required camp administration to segregate a small group of Italian prisoners who were declaring unpopular anti-fascist views. (Bushwhacker Museum.)

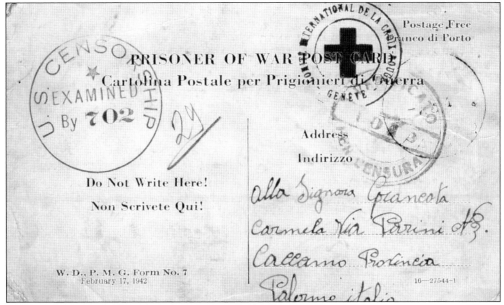

When prisoners of war arrived at Camp Clark, they were given the opportunity to fill out postcards from the International Red Cross, such as the one pictured, to inform their families of their internment location, physical condition, and mailing address. Additionally, the postcard had to pass review by military censors to ensure that no sensitive information was being revealed. (Jeremy P. Amick.)

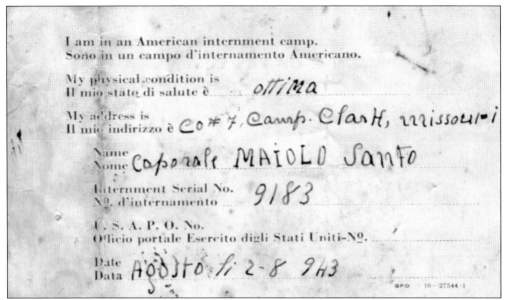

I am in an American internment camp.
Sono in un campo d'internamento Americano.

My physical condition is
Il mio stato di salute è _ottima_

My address is
Il mio indirizzo è _Co #7, Camp. Clark, missouri_

Name
Nome _Caporale MAIOLO Santo_

Internment Serial No.
Nº. d'internamento _9183_

U. S. A. P. O. No.
Officio portale Esercito digli Stati Uniti-Nº. _____

Date
Data _Agosto li 2-8 943_

GPO 16—27544-1

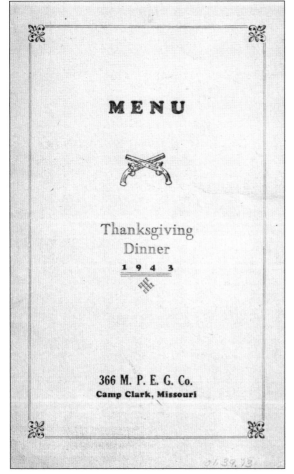

MENU

Thanksgiving
Dinner
1 9 4 3

366 M. P. E. G. Co.
Camp Clark, Missouri

Pictured is the back of an international postcard sent by a POW being held at Camp Clark to his family in Catanzaro, Italy. On the evening of May 18, 1943, five POWs escaped from Camp Clark but were later apprehended on a farm near Fidelity, Missouri. (Jeremy P. Amick.)

The 366th Military Police Escort Guard Company, under the command of Capt. Fred T. Mealey, arrived at Camp Clark in October 1942 and began a regimen of training to prepare them for guarding POWs in the coming weeks. Pictured is the cover of the menu for the Thanksgiving meal the company enjoyed at its dining facility in 1943. (Jeremy P. Amick.)

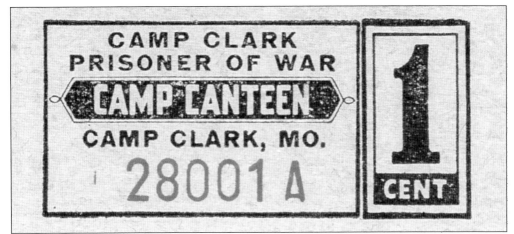

Many post exchanges during World War II assisted in the management of canteens where POWs could purchase items. Often, prisoners purchased merchandise from the post exchange and then resold it in the canteen they operated on behalf of their fellow prisoners. Pictured is one of the chits that a POW would have used in making a purchase at such a canteen. (Jeremy P. Amick.)

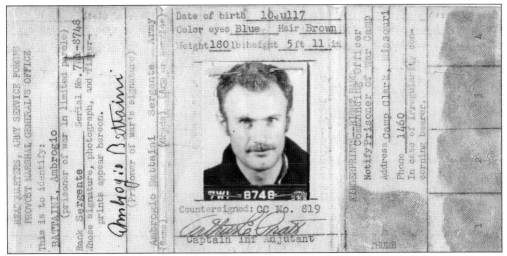

Italian POWs such as Ambrogio Battaini were issued identification cards such as these when arriving at Camp Clark. An interesting moment occurred at the camp on June 18, 1943, when Niccola Belasco, an Italian POW, was allowed to wed his bride in Italy by proxy. His fiancée went through the wedding rites at a Catholic church in Italy, and the papers were then forwarded to Camp Clark, where Rev. John Knoebler of a local church administered Belasco his vows and signed the appropriate papers. (Jeremy P. Amick.)

c 1201 (4 x)

Vorname—Surname	Name—First name
BUSCHING	RUDOLF

Date of birth Geburtsdatum 15. SEPTEMBER 1917	Place of birth Geburtsort BERLIN - PANKOW
Rank Dienstgrad OFW.	Unit Militärische Einteilung HEER
Army No. Beschriftung der Erkennungsmarke 127	Last civilian residence Letzter ziviler Wohnort BERLIN - SPANDAU

Family's address
Familienanschrift ERICH BUSCHING, BERLIN - SPANDAWS
FALSTAFF WEG 50.

Coming from (Camp No., Hospital No., etc.)
Komme von (Lager Nr., Lazarett Nr., u.s.w.) FORT DU PONT, DELAWARE

Captured: unwounded * slightly wounded * severely wounded * ill *
In Gefangenschaft geraten: nicht verwundet * ~~leicht verwundet~~ * ~~schwer verwundet~~ * ~~krank~~ *

Am well! * Am: recovered * convalescent *
Befinde mich wohl * ~~Bin geheilt~~ * ~~in Heilung~~ *

16—36582-1

Present address: P.O.W. No.
Gegenwartige Anschrift: Gefangenen Nr. 8WG —10150 Camp No. Lager Nr. COMPANY # 9

Locality MISSOURI Date
CAMP CLARK Datum 28 JAN. 1945 Signature Unterschrift *Rudolf Busching*

* Cancel what does not apply! No further details permitted! See explanation on reverse side!
* Nicht zutreffendes durchstreichen! Weitere Angaben nicht erlaubt! Siehe Erklärung auf der Rückseite!

With the surrender of Italy in September 1943, Italian POWs being held at Camp Clark began to be transferred to other camps in the United States. In June 1944, Camp Clark was placed on reserve status. However, the camp reopened a few weeks later and began receiving German prisoners of war. Pictured is a Card of Capture for Prisoners of War sent to the family of German POW Rudolf Busching, noting his transfer from Fort Du Pont, Delaware, to Camp Clark. (Jeremy P. Amick.)

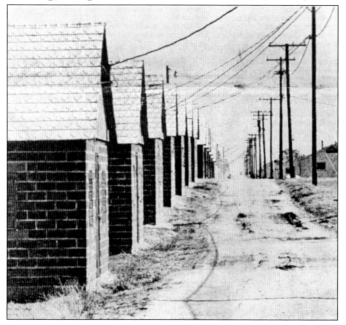

Pictured is a row of redbrick barracks along Reno Road near the POW compound as it appeared during World War II. The barracks have since been demolished and replaced with newer structures. (Museum of Missouri Military History.)

The soldiers assigned to Camp Clark in the latter part of World War II shared stories of goings-on through their own publication, the *Sentinel*. This copy was dated August 1945 and dedicated to the first anniversary of the camp's reopening after being closed briefly in the summer of 1944. (Jeremy P. Amick.)

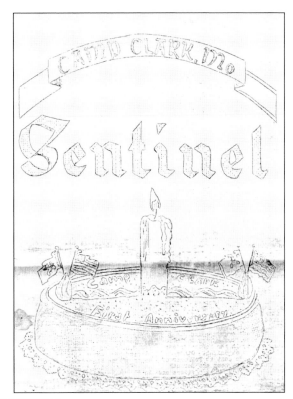

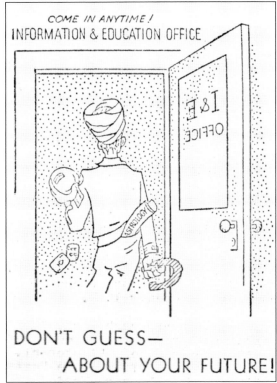

Advertisements were posted around Camp Clark to encourage soldiers to prepare for the future by visiting the Information and Education Office to investigate available high school, college, and trade courses. (Jeremy P. Amick.)

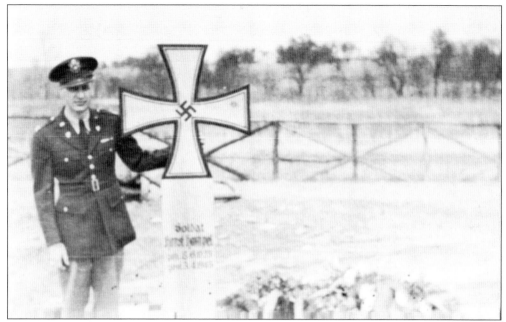

There were no vestiges of Naziism allowed to be displayed by prisoners on Camp Clark. The exception to this was in the instance of the death of a POW—the burial was to occur with full military honors based upon the customs of the country. A US soldier stands next to the burial site of a German POW who died while in captivity at Camp Clark. (Bushwhacker Museum.)

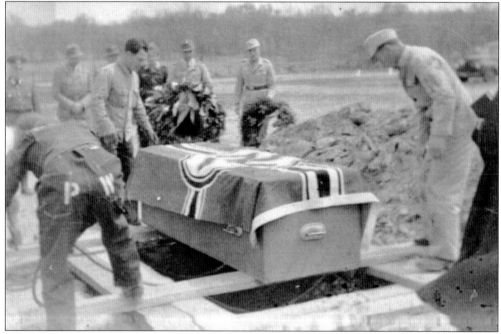

During the height of its activity, there were 5,500 German POWs in captivity at Camp Clark. In early August 1945, three German POWs were killed near Harrisonville, Missouri, while being transported from Camp Clark to Algona, Iowa. POWs who died while in captivity were interred in a small cemetery near the western edge of Camp Clark. (Bushwhacker Museum.)

After the end of World War II, the graves of the POWs who died at Camp Clark were exhumed and their remains returned to their home country. The staff at Camp Clark continues to maintain the small site where the POW burials once occurred. (Jeremy P. Amick.)

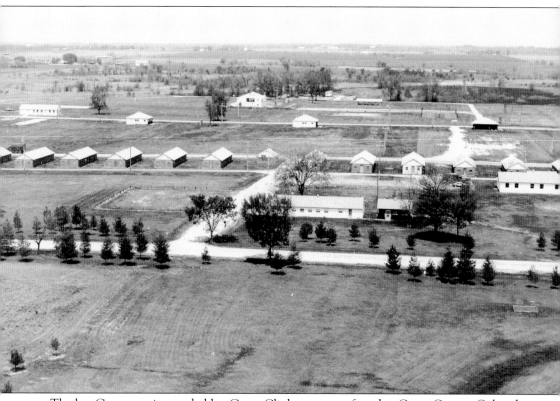

The last German prisoners held at Camp Clark were transferred to Camp Carson, Colorado, on September 21, 1945, and several weeks later, the camp was placed on inactive status. Many of the POW barracks were demolished or sold after the war. (Museum of Missouri Military History.)

Five

CAMP CLARK
IN LATER YEARS

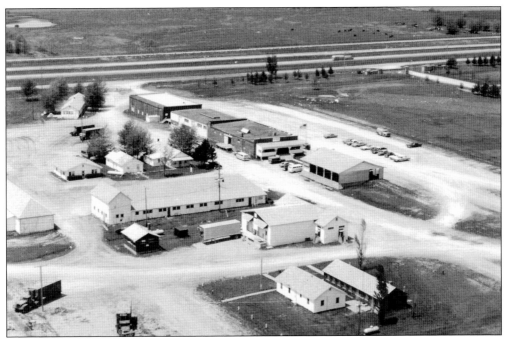

Alarming news was reported in January 1946 when the War Department released a statement that Camp Clark was to be declared surplus and sold, with the Missouri National Guard moving to Fort Leonard Wood. Through a campaign organized by citizens and business owners of the Vernon County community, the decision was made to retain the historic camp as a Missouri National Guard training site. The headquarters area is seen in this aerial photograph from 1973. At the time, it encompassed 1,287 acres. (Museum of Missouri Military History.)

The 135th Heavy Tank Battalion was established as part of the effort to maintain Camp Clark when discussions were underway regarding its disposition. After the camp was returned to the Missouri National Guard as a training site, the tank companies of the Missouri National Guard utilized the camp for maneuvers. (Museum of Missouri Military History.)

Although Camp Clark provided an ample landscape to train in tank maneuvers, many tank companies from Missouri had to travel to much larger training locations out of state to fire their main guns. Camp Clark did not possess adequate acreage for such training to be safely conducted. (Museum of Missouri Military History.)

Officers of the 135th Tank Battalion pose for a photograph during their annual training at Camp Ripley, Minnesota. The battalion frequently conducted limited maneuver training at Camp Clark on various tank trails. In the late 1960s, many of the tank units converted to engineer units, hailing the end of tanks in the Missouri National Guard. (Museum of Missouri Military History.)

Following training maneuvers on Camp Clark, units would utilize this wash rack to clean the mud and debris from their tanks. The wash rack still stands on the south side of the camp, although it is no longer used. (Jeremy P. Amick.)

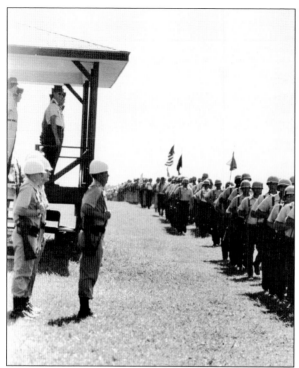

For many years after World War II, Camp Clark was primarily used as an equipment maintenance and storage site and a location for small arms firing in addition to a weekend training location. In the early 1960s, it underwent significant rehabilitation and began to be used regularly as an annual training site. Pictured is a unit in the late 1950s doing a pass and review on the parade field at Camp Clark. (Museum of Missouri Military History.)

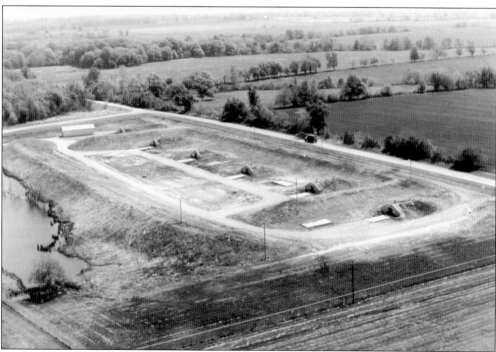

By the 1970s, Camp Clark had established a 40-point known-distance rifle range, a pistol range, a machine-gun range, and a grenade launching range. This five-acre ammunition storage area was erected and includes six concrete igloos. The small pond adjacent to the ammunition storage area was later filled. (Museum of Missouri Military History.)

Camp Clark has for many years served as the ammunition supply point for the Missouri National Guard, providing ammunition for units conducting marksmanship qualifications and associated training while also storing ammunition in the case of state emergencies. Pictured is a wooden ammunition crate from 1937 that once held .50-caliber cartridges. (Jeremy P. Amick.)

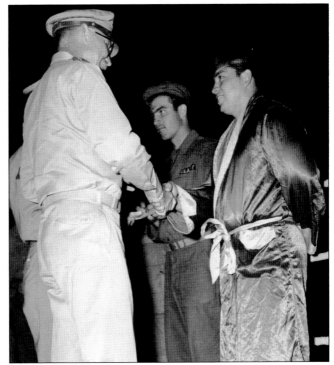

An exciting form of entertainment for the Missouri National Guard soldiers in training at Camp Clark was boxing matches. At one time, there was a boxing ring inside the gazebo on the South Lake, while in later years, a boxing ring was used in the basement of the main administration building. (Museum of Missouri Military History.)

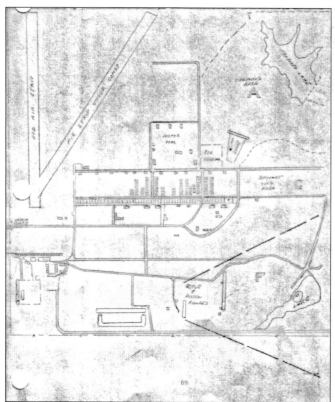

This map from the late 1960s or early 1970s shows the location of important training areas on Camp Clark, including the bayonet training area and the rifle and pistol ranges. On the northeast section of the post was a proposed lake, which was built in 1975 and is now referred to as the North Lake. (Museum of Missouri Military History.)

CWO4 DeForest Ratterree is pictured in 1968 with a 1927 Chrysler staff car that was found under a stack of hay in an old cavalry stable on Camp Clark in 1947. The vehicle had been the property of the US Army and was left behind when Camp Clark was turned over to the Missouri National Guard. (Museum of Missouri Military History.)

The 1927 Chrysler was restored and used for many years by staff at Camp Clark for area parades and other public events. It was eventually brought to Jefferson City and underwent another, more thorough restoration and is now on display in the Museum of Missouri Military History at the Missouri National Guard Headquarters. (Jeremy P. Amick.)

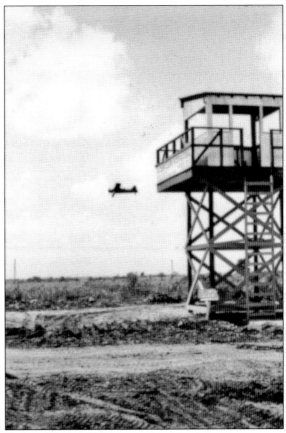

One of the improvements made to Camp Clark in later years was the construction of a 4,000-foot grass airfield to be used by light aircraft. In the early 1970s, Missouri National Guard units such as the 1140th Engineer Battalion and the 135th Engineer Group performed much of this work. (Museum of Missouri Military History.)

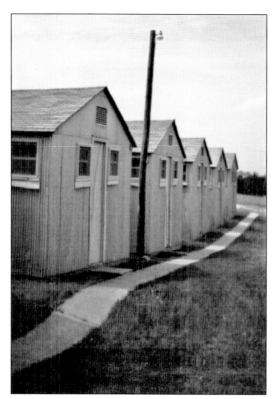

For many years, the State Officer Candidate School program was operated at Camp Clark, embracing the availability of classrooms, a land navigation course, weapons ranges, and tactical training areas. Pictured are the tin hutments, now demolished, that were used in the officer candidate school area. (Museum of Missouri Military History.)

Col. James J. Mayes was the commander at Camp Clark from May 1964 until February 1973. Enlisting in the Missouri National Guard in 1937, he served in the active US Army during World War II and fulfilled several roles, including infantry platoon leader, company commander, supply officer, and battalion adjutant. Mayes, who later retired from the Missouri National Guard, passed away in 1997 and was laid to rest in Hawthorn Memorial Gardens in Jefferson City. (Jeremy P. Amick.)

Col. Walter C. Wilson served as the commander of Camp Clark from February 1973 to January 1975. Wilson enlisted as a private in 1934 in the Missouri National Guard's Battery C, 128th Field Artillery, in Maryville. During World War II, he was commissioned a second lieutenant and served with the 927th Field Artillery Battalion and the 102nd Infantry Division, earning a Silver Star. The 83-year-old veteran passed away in 1999 and is interred in Riverview Cemetery in Jefferson City. (Jeremy P. Amick.)

Col. Dale L. Strannigan filled the role of complex commander at Camp Clark from February 1975 to January 1984. Previous to his role at the camp, Strannigan served as the executive officer for the 205th Medical Battalion in Kansas City and was for many years a member of the US National Guard Rifle Team. The Kansas City–area native was 77 years old when he passed away in 2012. (Jeremy P. Amick.)

CWO4 DeForest Ratterree served in the South Pacific with the US Army during World War II, earning three Bronze Stars. After the war, he joined the Missouri National Guard and went on to serve 30 of his 34 years at Camp Clark. When Ratterree retired in 1976, he was officer in charge of the camp. The veteran passed away in 2013 and is interred in Fort Scott National Cemetery in Kansas. (Jeremy P. Amick.)

CWO4 Sherman Neblett was a longtime member of the Missouri National Guard and served with many maintenance units within the organization. He became the post engineer at Camp Clark and is credited with designing its water treatment and sewage treatment systems. The veteran died in 1992 and is buried in Riverview Cemetery in Jefferson City. (Jeremy P. Amick.)

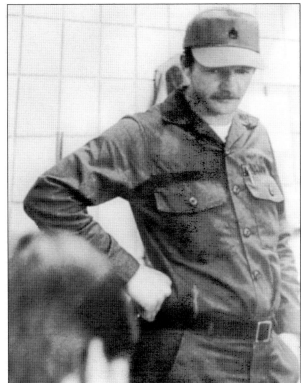

First Sgt. Stephen "Frank" Arnold enlisted in the Missouri National Guard in 1967 and retired in 2009 as maintenance shop chief at Camp Clark. In 1975, he helped battle a fire on the camp that destroyed old horse barns being used as storage buildings, earning a Missouri Conspicuous Service Medal for his efforts. (Jeremy P. Amick.)

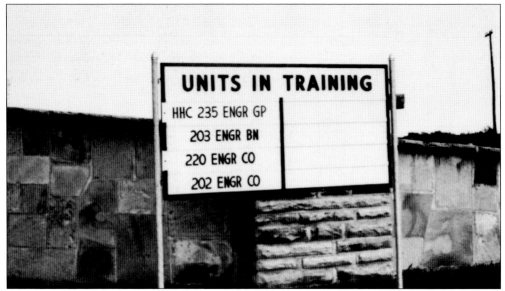

A small sign outside the front gates denotes the Missouri National Guard units in training at Camp Clark during the early summer of 1970. Several months later, it was announced that the Department of Defense had approved $100,000 in improvements at Camp Clark: $40,000 for a new elevated water tower and $60,000 to rebuild the main electrical distribution system. (Museum of Missouri Military History.)

In the summer of 1973, 1st Platoon, Company A of the 203rd Engineer Battalion embraced having skilled trades personnel in the unit by erecting this barbecue grill on the South Lake of Camp Clark. Weeks earlier, 300 members of the 203rd Engineer Battalion were activated for state emergency duty in response to damage caused by a severe windstorm in Joplin in early May 1973. (Museum of Missouri Military History.)

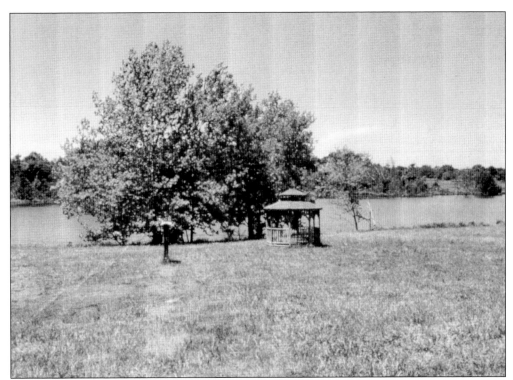

Pictured is a section of the North Lake on Camp Clark. Construction of the lake began in 1975, and it is now used for fishing and as a recreational area for soldiers stationed at the camp or those staying onsite for training. (Jeremy P. Amick.)

For many years, this decal was required to be displayed on a vehicle's bumper or windshield by full-time personnel and regular visitors entering Camp Clark. Today, visitors must check in with a guard when entering the post. (Bushwhacker Museum.)

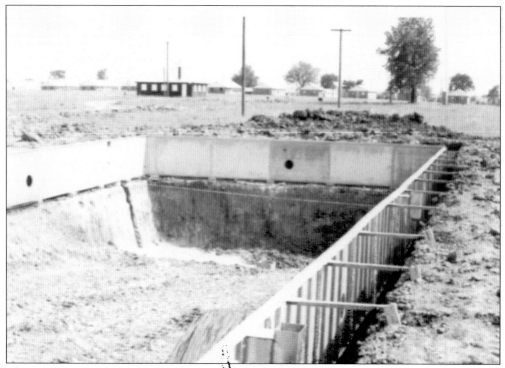

The swimming pool on Camp Clark began on April 17, 1975, when all of the necessary equipment was ordered. Four days later, the excavation work started. By May 13, 1975, the reinforcing steel was in place, and the concrete bottom was poured the following day. (Museum of Missouri Military History.)

The first use of the new pool on Camp Clark occurred on July 15, 1975. The pool continues to be maintained on the post and is used by full-time employees and their families in addition to any troops visiting the site for training. (Museum of Missouri Military History.)

A winter storm struck the Nevada area in February 1990, dropping freezing rain and making travel nearly impossible. Pictured are the ice-covered trees along the main entrance of Camp Clark following the storm. (Museum of Missouri Military History.)

First Sgt. (retired) Stephen "Frank" Arnold shared that this mural of the US Army Quartermaster Corps emblem was painted on the wall inside the administration building at Camp Clark sometime in the early 1990s. The emblem is in the center section of the building that is used for storage and measures approximately 10 feet by 12 feet. (Jeremy P. Amick.)

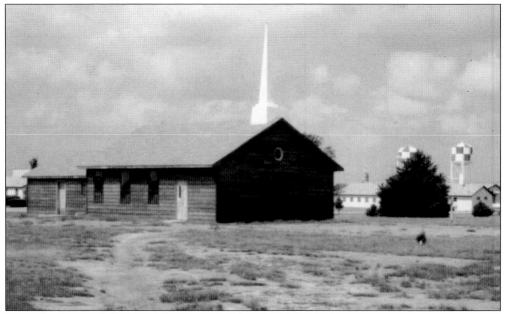

A fundraising effort began in the late 1980s for a chapel to be built on Camp Clark. The effort proved successful, and by 1990, the building was essentially completed. Throughout the years, the chapel has not only been used for worship services but has also hosted wedding ceremonies for many members of the Missouri National Guard. (Jeremy P. Amick.)

A nod to the past is still seen on the post in this tin-covered building that was once used as a gas chamber, where tear gas was used to help train soldiers in the proper use of gas masks. The building is near the old rifle range on the south side of Camp Clark. (Jeremy P. Amick.)

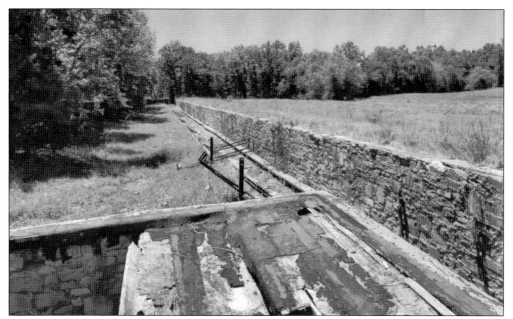

The backstop and the pit of the original rifle range is pictured as it appears today; this range is no longer used by the camp. In more recent years, the camp has been home to other ranges, including a practice grenade range, a combat pistol qualification range, and a 25-meter zero and qualification range for M-4 and M-16 rifles. Since the camp no longer possesses the necessary acreage to allow for a safe buffer from adjoining properties, rifle qualifications are conducted at other locations, such as Camp Crowder and Fort Leonard Wood. (Jeremy P. Amick.)

Today, there is little evidence of the dozens of POW barracks and other buildings that sprawled across the northern section of Camp Clark during World War II. Pictured is a section of a concrete foundation of one of these former structures. Many of the foundations had to be removed over the years as they became obstacles for the mowers cutting grass in the area. (Jeremy P. Amick.)

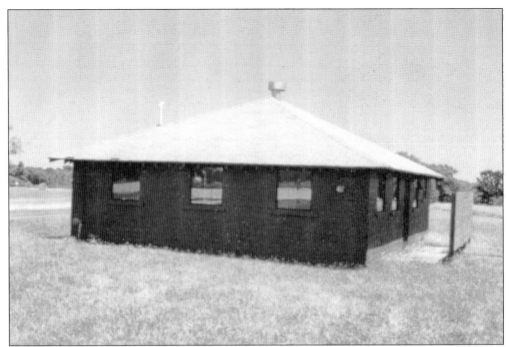

Few buildings remain on Camp Clark that date to World War II and earlier. This barracks building has been restored and maintained on the complex, and though not being actively used, it provides a tangible connection to the camp's past. (Jeremy P. Amick.)

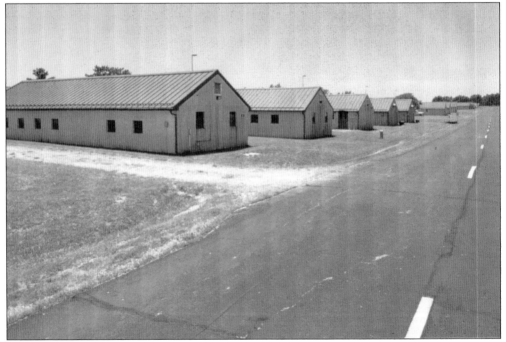

Newer buildings continue to be erected to serve as barracks, classrooms, dining facilities, and gymnasiums. These buildings not only support Missouri National Guard soldiers during their annual training but have also been used for pre-mobilization training activities. (Jeremy P. Amick.)

One of the features on the camp is a state facilities maintenance shop. Pictured is a section of Field Maintenance Shop No. 15, which was constructed in 1975 and has been updated in recent years to include vehicle maintenance bays. (Jeremy P. Amick.)

Pictured is the south side of Building 131, which continues to serve as the headquarters building for Camp Clark. The west side of the expansive building houses the Ammunition Supply Point, which controls range usage and ammunition supply. (Jeremy P. Amick.)

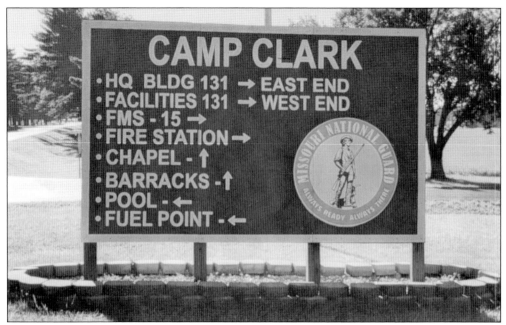

This sign greets visitors as they enter Camp Clark through the main gate, directing them to the primary sites on the post. The dividing line of the camp is Sheppard Road—the northern half of the camp is owned by the state, and the southern half is federally owned and licensed to the Missouri National Guard. (Jeremy P. Amick.)

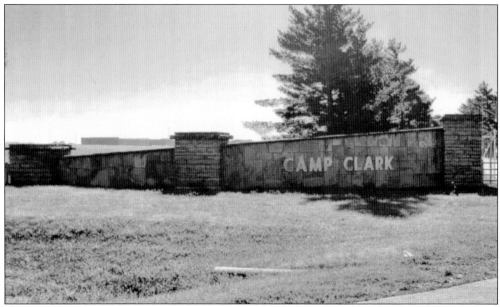

Since its beginning in 1907, several generations of Missouri National Guard troops have received training at Camp Clark that has prepared them for service in wars and global conflicts. It has been home to Italian and German prisoners of war during World War II and continues to serve as a treasured resource for the Missouri National Guard, demonstrating on a daily basis a respectable balance between the preservation of a rich history and expansion into a modern military training location. (Jeremy P. Amick.)

BIBLIOGRAPHY

"Another Soldier Drummed Out of Camp Dockery After Court Martial." *St. Louis Republic*. July 25, 1901, 2.

"Camp Clark Pay Roll Guarded by Twenty Soldiers." *St. Louis Star and Times*. September 17, 1917, 2.

"Camp Clark, Years Ago Made Home of Nazi Captives, Now Biggest Camp of Kind." *Nevada Herald*. August 9, 1945, 2.

"Colonel Mitchell, the Gallant Soldier, Answers the Bugle Call." *Southwest Mail*. December 16, 1921, 8.

"Dr. Troesch, Top Borrower, Looks for Clothing of 1909 Vintage." *Nevada Herald*. November 30, 1944, 1.

Fiedler, David. *The Enemy Among Us: POWs in Missouri during World War II*. St. Louis, MO: Missouri Historical Society Press, 2003.

"Full Mobilization of State Guard is Likely This Week." *St. Louis Star and Times*. August 13, 1917, 3.

"Many at M.N.G. Encampment." *Kansas City Times*. August 26, 1913, 5.

"Missouri National Guard." *Southwest Mail*. July 26, 1901, 3.

"Night at Warlike Front." *Kansas City Star*. August 7, 1935, 3.

"Only Officers at Camp Hadley." *St. Joseph Gazette*. June 28, 1910, 1.

"Sham Battle Thursday in Which Missouri Troops Engage Enlivens Camp Dockery." *St. Louis Post-Dispatch*. July 25, 1901, 4.

"Troops Leave for Camp." *St. Louis Globe-Democrat*. July 16, 1909, 9.

"$5,000,000 Work at Leonard Wood." *Springfield News-Leader*. October 16, 1942, 26.

DISCOVER THOUSANDS OF LOCAL HISTORY BOOKS FEATURING MILLIONS OF VINTAGE IMAGES

Arcadia Publishing, the leading local history publisher in the United States, is committed to making history accessible and meaningful through publishing books that celebrate and preserve the heritage of America's people and places.

Find more books like this at
www.arcadiapublishing.com

Search for your hometown history, your old stomping grounds, and even your favorite sports team.